PEN&INK
DRAWING

D1105211

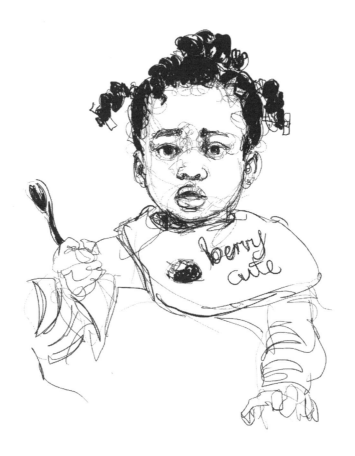

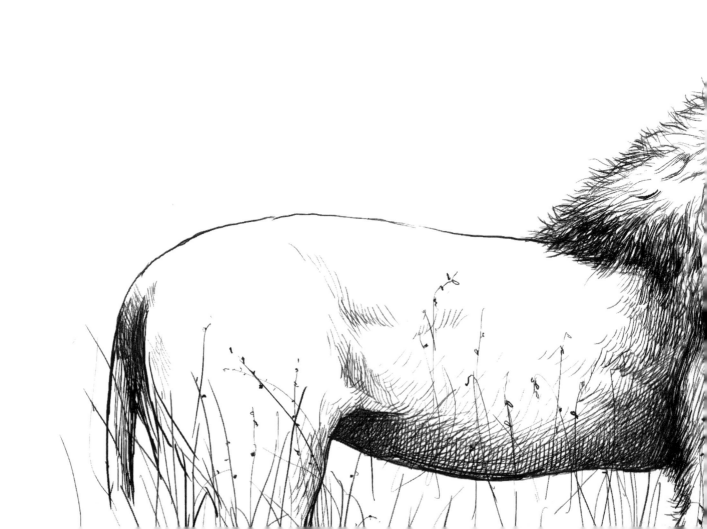

PEN&INK
DRAWING
A SIMPLE GUIDE

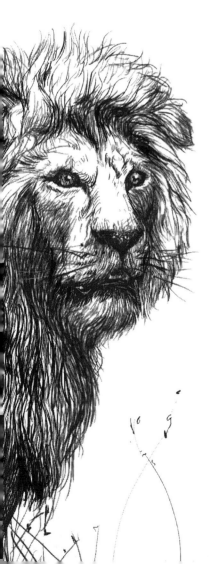

ALPHONSO DUNN

THREE MINDS PRESS

Woodland Park, New Jersey

ABOUT THE AUTHOR

Alphonso Dunn is an accomplished artist with a strong background in the sciences. Born in Jamaica, he moved to the United States at age 17. Inspired by childhood ambitions for a career in medicine, he completed his undergraduate study in Applied Chemistry at William Paterson University; however, his life-long passion for drawing led him to earn a Master of Fine Arts from the New York Academy of Art. Since completing his graduate study, he has taught college-level art courses and high-school science classes. He is the recipient of numerous awards, and his work can be found in private collections nationwide. He currently resides in New Jersey.

Senior Editor: Kisha Edwards-Gandsy
Associate Editor: Loraine Laidlaw
Cover Design: Bob Fillie

Copyright © 2015 by Alphonso Dunn.
All rights reserved. No part of this publication may be reproduced or used in any form or by any means—graphic, electronic, or mechanical, including photocopying, recording, taping, or information storage and retrieval means—without written permission from the publisher/author.

Library of Congress Control Number: 2015919869
Published by Three Minds Press
Woodland Park, New Jersey

Dunn, Alphonso.
 Pen and Ink Drawing: A Simple Guide
 1. Pen drawing—Technique. I. Title.
 ISBN-13: 978-0-99704-653-3
 ISBN-10: 0-99704-653-8

First Edition. First paperback printing, 2015

Manufactured in the United States of America.

To my family, friends, and lovers of drawing everywhere

CONTENTS

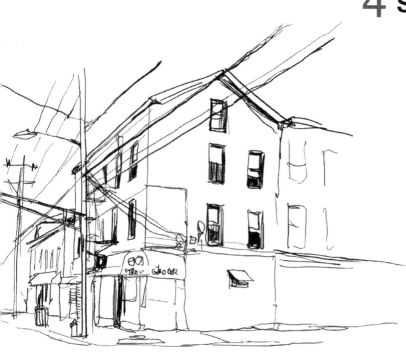

Start-up

Doodle here! ☺

Why Pen and Ink?

Pen and Ink drawing comes with several unique demands and challenges when compared to other drawing media. For example, it's linear and not erasable, which means completing a polished drawing may require considerable amounts of time, patience, and attention to detail. Knowing this, why bother at all? Because drawing in ink can be one of the most rewarding, liberating, and insightful creative experiences.

Beginners are often most intimidated by the fact that ink is not erasable. Ironically, they learn quickly that this is what teaches you to ignore "mistakes" and to just keep drawing, not getting fixated on getting things right. Not being erasable makes pen and ink perfect for gesture drawing and quick sketches where spontaneity, speed, and immediacy are of essence.

In addition, being linear in nature makes pen and ink seem daunting to those who are more comfortable drawing with tone or a painterly approach. However, rendering with lines enhances your perception of the volume and cross-contour of forms. If you closely examine the surface of many sculptures, you will witness evidence of cross-hatch marks left by sculpting tools. Drawing with ink is like slowly sculpting forms to life.

And when it comes to creating polished drawings where accuracy and attention to detail is essential, drawing with ink teaches you to slow down, plan, and layout the drawing in advance. This makes you more critically aware of the creative process, which involves planning steps, evaluating choices, and developing a finished piece in stages.

Start talking to yourself

Many students experience very slow progress in drawing because they haven't learned that it involves much more than simply putting what they look at on paper. Instead, it's more about how you think of, and process, what you see. They may have been taught to just copy what's in front of them, with little or no involvement in a critical process. Many books show countless snapshots of what the various steps of a drawing should look like, but provide little emphasis on the thinking involved between the steps.

What about the things you should see but may never literally put down on paper? This concern takes center stage in my style of instruction. Drawing should always involve a critical dialogue between your eyes, mind, and hand. It's not only what you perceive that matters, but how you process that information before it's translated to paper. This inevitably leads

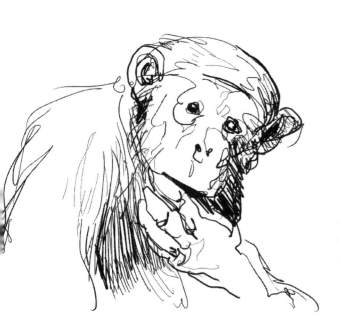

circl

write notes inside this book

you to question, should you copy everything you see? What's important and what's not? And to what end do you make that determination? These and other questions are critical to understanding the thought process of drawing and enable you to have a much more fulfilling experience.

Many of the concepts I share are more relevant to how you should be thinking as you draw and not always to what is to be drawn literally. For instance, sometimes you may not find it necessary to start a drawing with construction lines or simple shapes, but you should definitely always think about them.

My goals for this book:

I hope that after completing this book you will:

- Learn invaluable concepts, skills, and techniques that will significantly improve your rendering with pen and ink.
- Understand that drawing is as much a mental activity as a mechanical one.
- Appreciate the uniqueness, versatility, and expressive power of drawing with ink.
- Use all you learn to further enrich your life.

What is expected of you?

Learning is a two-way street, and to get the most from this learning experience you must:

- Be Patient. Some things just cannot be rushed. Learning to draw with ink is one of them.
- Be willing to practice the same thing over and over again. Repetition is the mother of learning.
- Understand that learning isn't always fun. Some things will feel like boring drills, but just do them. All that you do will pay off eventually.
- Be Persistent. Don't give up after your 1st, 2nd, 3rd, 4th… or 100th attempt. Celebrate the small steps of your journey and keep going.
- Aim big; start small. Don't underestimate the basics. It all starts there.
- Be positive. Having the right attitude is half the job. Don't be too hard on yourself or be quick to compare yourself to others. Compete with you.
- Believe in yourself. Know what you're capable of and let no one tell you otherwise.

Practice in this book

ortant stuff

Supplies

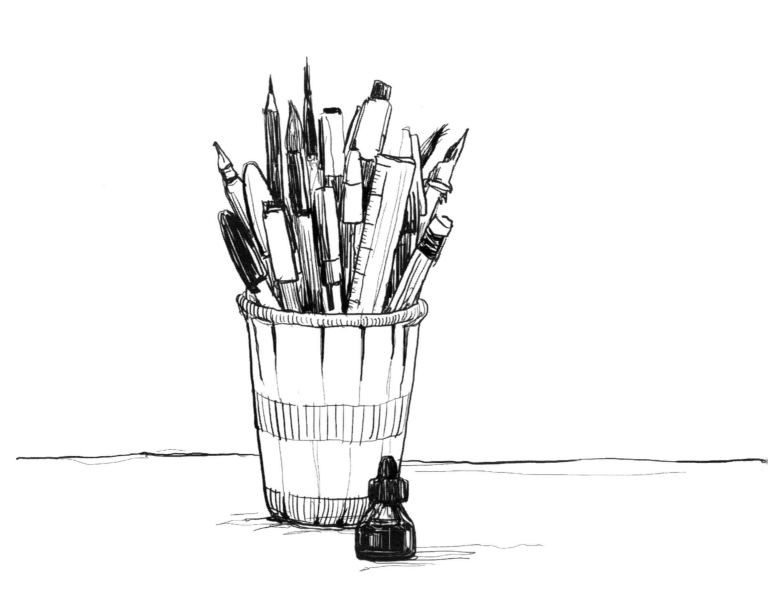

With the wide variety of pen and ink drawing materials available today you can easily feel overwhelmed at the thought of what supplies are best to start with. Although it is generally recommended that you get the best quality supplies when possible, with just a cheap ballpoint pen you can still create splendid pieces. This suggests that understanding the essential concepts of pen and ink drawing, developing basics skills and techniques, and exploring your creative potential are the things that should really matter most when just starting out. Sometimes stalling at what supplies to buy can become just another hindrance to deter you from getting started. In fact, virtually anything that can make marks can be used to create ink drawings. It is that simple!

Try to research and experiment with different products and brands to see what suits you best. Don't buy supplies solely based on brand names. Often you will find that, for a given product and the brands who sell it, there are significant differences in price but minor differences in quality. You will also learn quickly that some brands are only good for certain products. For instance, one brand may offer high quality dip pens, while another may offer high quality ink. You may like the brush pens of one and the fountain pens of another. Ultimately, try to find a comfortable middle ground between your budget, comfort, and quality.

As you become more comfortable with using various instruments you will eventually develop a sense of what works best for you and the types of drawings you want to create. Some instruments are more suited for technical works and details and others for gestural marks and quick studies. Try to expose yourself to as many different types of of instruments as possible. But remember; if a cheap ballpoint pen and notepad are all you have, that's enough to get going!

Basic Supplies

You really don't need much to get started with pen and ink drawing. Consider this your basic start-up kit:

- pen
- pencil
- drawing pad

INK

There are two main types of inks available for pen and ink drawing: pigment-based and dye-based inks. Pigment inks are generally opaque, archival, and water resistant, but are often not available in a wide variety of colors. Dye-based inks are more popular for their brilliant colors and versatility, but are generally not as permanent or water-resistant. Be aware that some inks only work well with particular instruments. For example, pigment inks may be suitable for nib and technical drawing pens but not for most fountain pens.

For finished works use inks that are permanent, waterproof, and smudge-resistant. These characteristics allow you to erase pencil underdrawings or add wet media without interrupting your ink work. Indian ink has been a favorite among artists for its versatility, permanence, and the rich black it produces. It can be diluted with water to create gray washes, yet is waterproof when fully dried.

Characteristics to consider when buying ink:
- Permanence. The ability to resist fading or discoloration over an extended period of time or when exposed to direct light.
- Water-resistance
- Ease of flow
- Smudge/smear resistance
- Use with various Instruments
- Use with wet media
- Matte or glossy finish
- Drying time

PAPER

When your plan is to create finished or fully rendered drawings that you hope will last for a long time it is important to use the right paper. While a regular drawing pad or sketchbook is always good to have for practicing or sketching on the go, recommended choices for creating finished pieces includes, bristol board, watercolor pads, illustration board, or acid-free mixed-media sheets.

Characteristics to consider when buying paper:
- **Weight** Heavyweight is best to prevent ink from bleeding and to prevent crumpling should you apply wet media such as watercolor.
- **Texture** Smooth is best for clean line work, smooth nib movement, and consistent ink flow. Paper that is too textured can damage your pen nib, compromise line quality, and cause unwanted feathering.
- **Preservation** Acid-free or archival paper is resistant to discoloration and deterioration from exposure to direct light, and well suited for preserving finished drawings.

COMMON INK DRAWING INSTRUMENTS

Pens

- Quill pens
- Reed or bamboo pens
- Dip pens
- Fountain pens
- Technical drawing pens
- Ballpoint pens
- Rollerball pens
- Felt-tip pens and markers

Brushes

- Paint and ink brushes
- Water brushes
- Brush pens

Quill pens

Quill pens are one of the oldest ink drawing and writing instruments. A quill pen is a pen made from the main wing or tail feathers of a large bird. The specially shaped tip has a fine slit that allows ink to flow up by capillary action. You simply dip it in a container of ink to start drawing.

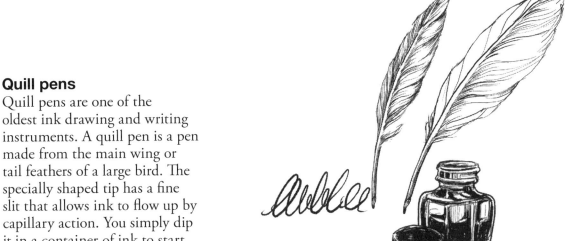

Reed or bamboo pens

Reed pens are very similar in structure to quill pens but are made from a single reed shaft or thin piece of bamboo, instead of a quill feather. The quill and reed pen are the two most common types of ink drawing instruments made from natural materials.

Dip pens

Quill and reed pens led to the development of the dip pen. A dip pen is made up of just a nib holder and a nib. The nib is the metallic end part that is fastened into the holder, which is generally made of wood or hard plastic. Nibs come in different shapes and sizes, which enables you to create a wide variety of lines. The metal nib makes a dip pen much more durable than a quill or reed pen, whose tip can quickly deteriorate over time. Some nibs are designed to hold surplus ink allowing you to draw for longer periods before reloading.

Fountain pens

Think of fountain pens as dip pens with a self-contained reservoir of ink. They generally function best with water-based inks and are designed with a special mechanism to regulate the flow of ink to the nib. Some have refillable reservoirs, while others have replaceable ink cartridges. These and other advancements make them much pricier than dip pens.

Ballpoint pens

The fact that they are cheap, efficient, and durable makes these the most commonly used pens for writing. Because of their thick paste ink and ballpoint mechanism some effort is required to make bold marks. This allows you to make marks with a wide range of tones like you would with a pencil. You should bear in mind that these pens are designed for everyday writing and not for creating lasting fine art, so the ink is not guaranteed to be archival.

Rollerball pens

Rollerball pens are made with a mechanism similar to ballpoint pens but dispense a less viscous water-based or gel ink. This type of ink allows the pen to write more smoothly and create solid marks with little effort.

Technical drawing pens

These are a favorite among artists. Their inks are generally archival and water-resistant making them well-suited for fine art. They also come in a wide variety of nib sizes to facilitate fine detailing or bold mark-making. They provide smooth handling and create clean lines with consistent widths. Some are entirely disposable after the ink runs out, while others allow you to refill or replace ink cartridges.

Markers and felt-tip pens

These are very popular because of their availability in a wide range of colors, prices, and point sizes. They are very versatile and are commonly used for coloring, sketching, labeling, drawing, and writing.

White ink pens

White ink pens are invaluable for creating marks and highlights on a dark colored surface or background. In pen and ink drawing they can be used to convey textures, bright spots and highlights where the white of the paper is not applicable. They can also be used for making small corrections.

Brush pens

You can think of these instruments as pens with a brush-like tip. Unlike actual paint brushes, their tips lack individual bristles, but are made of a soft flexible material that gives to pressure. In turn, this creates elegant, flowing lines like a paint brush. Some are available with refillable ink reservoirs or replaceable cartridges, while others are disposable after the ink is depleted.

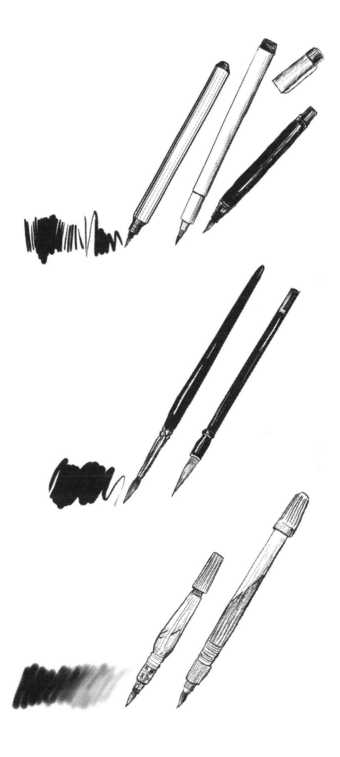

Paint brushes

Paint brushes are another popular choice for rendering ink drawings because of their impressive versatility. Many artists believe they can match or surpass pens in virtually every aspect. They are available in a wide variety of shapes, sizes, and builds to meet most ink drawing needs. With one brush you can create both intricate details and broad washes.

Water brushes

These brushes remove the need to continually dip your brush in water by having a handle that serves as a water or ink reservoir. Just fill the reservoir, attach the brush tip, and you're ready to go!

UNCONVENTIONAL INSTRUMENTS

This includes virtually anything that can be used for making marks in ink, whether it be a twig, a sponge, an old toothbrush, or even your fingertips. Think of other simple things you could convert to ink drawing instruments. Let nothing stop your creativity!

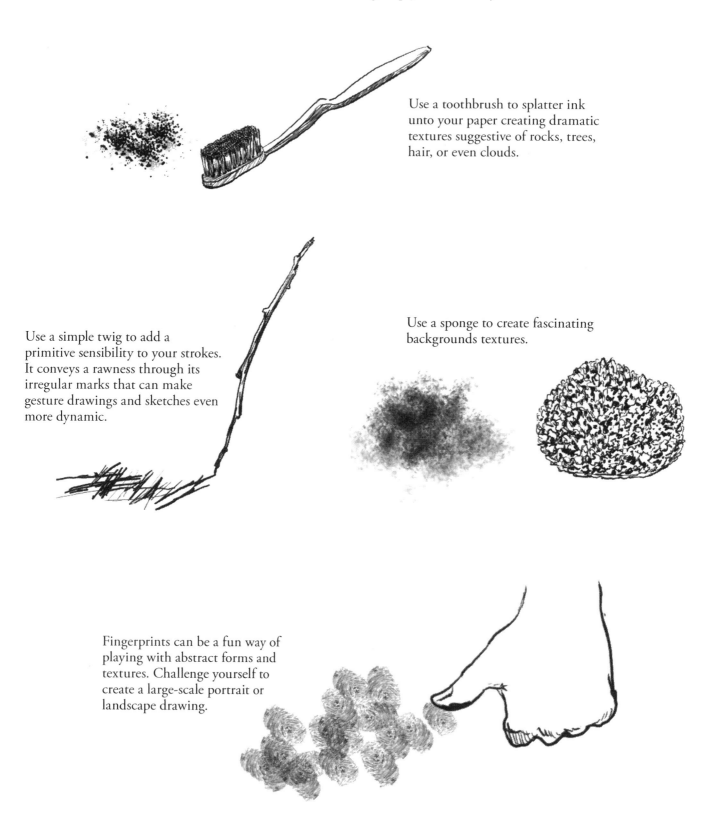

Use a toothbrush to splatter ink unto your paper creating dramatic textures suggestive of rocks, trees, hair, or even clouds.

Use a simple twig to add a primitive sensibility to your strokes. It conveys a rawness through its irregular marks that can make gesture drawings and sketches even more dynamic.

Use a sponge to create fascinating backgrounds textures.

Fingerprints can be a fun way of playing with abstract forms and textures. Challenge yourself to create a large-scale portrait or landscape drawing.

ADDITIONAL SUPPLIES

In addition to your ink drawing instruments, there are a few useful accessories to have in your arsenal. Always keep a small sketchbook on hand for quick studies when on the go. Keep at least two drawing pads: one for practice, and the other for finished drawings.

Erasers are essential for cleaning up pencil underdrawings. A kneaded eraser is gentle enough for erasing without disturbing ink work and other erasers such as, plastic erasers, are useful for removing stubborn traces of pencil. Using a dust brush allows you to remove small debris without the risk of smearing your drawing with your hands.

For underdrawings, a regular HB pencil is ideal because it isn't too hard that it would score the paper nor is it too soft that it would easily cause smudges and smears.

sharpener

clear ruler

mechanical pencil

graphite pencils

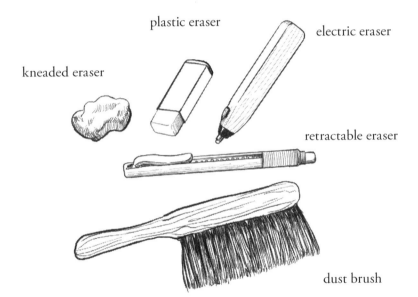

plastic eraser

electric eraser

kneaded eraser

retractable eraser

dust brush

sketchbook, drawing, watercolor, and bristol pads

Strokes

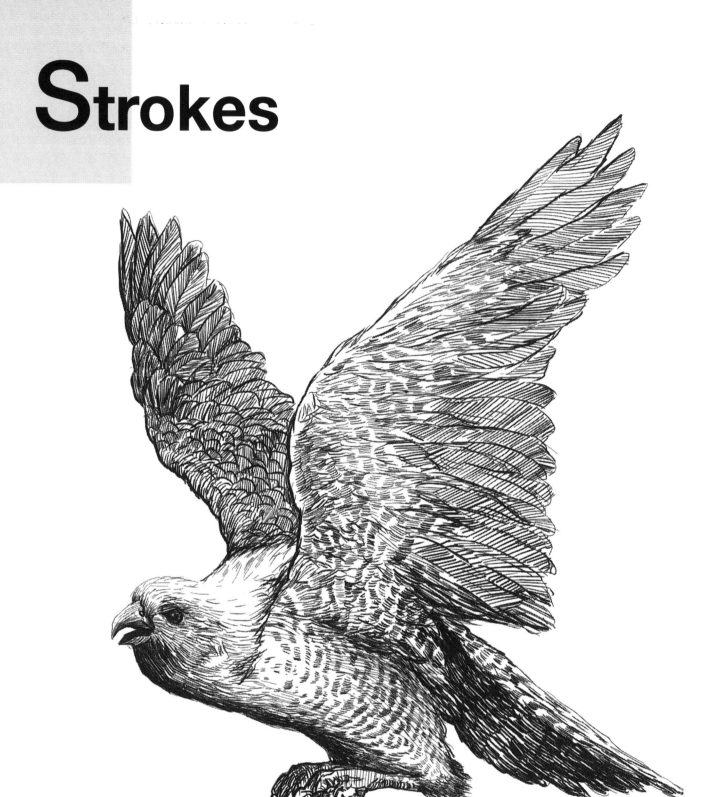

A stroke can be any mark you make on paper or refer to a particular type of mark-making. For example, stippling and hatching are two types of strokes because each consists of its own type of consistent mark-making. In pen and ink drawing, your strokes are the nuts and bolts of every image you create. With them, you can design patterns, indicate textures, convey light and shadow, and describe all the other aspects of a subject. Understanding that strokes have this ability to serve multiple functions enables you to be more aware of how you use them and less likely to lay them down arbitrarily. The most common error when starting out in pen and ink drawing is not spending the time necessary to develop fundamental mark-making skills and techniques.

Five tenets to developing core ink drawing skills:
1. Develop pen control.
2. Acquire command of the basic strokes.
3. Apply strokes with consistency.
4. Know the ways to vary a stroke.
5. Know the basic uses of a stroke.

Get a grip of your pen
Your drawing pace, arm movement, and grip of the pen can affect your line quality. Adjust each of these attributes depending on the needs of your drawing. Your pen control when making quick gesture studies would not be the same as when rendering fine details.

Know your basic strokes
It is important to acquire command of the basic types of strokes and consider them the "letters" of your pen and ink drawing alphabet. Study the drawings of many artists proficient with pen and ink and you will find that there are only a few recurring strokes in most of them.

Keep your mark-making consistent
Being consistent with your mark-making lies at the heart of pen and ink drawing. Consistency refers to being uniformed in the ways of varying a stroke in relation to the purpose of the stroke. Because you can vary a stroke in several ways, being aware of which variation you choose and keeping it uniformed is important to achieving and maintaining the intended effect.

Control the properties of your strokes
The visual effects created in ink drawings are acquired primarily from the variations of strokes. Each variation has a plethora of uses, and as you learn them you will become more resourceful with your approach to different subjects.

EFFECTIVE PEN CONTROL

Everyone will not hold a pen in the same way. However, it is important to practice consistent pen control that will facilitate achieving dexterity. While there are no hard-fast rules about how you should hold your instrument, keep the following points in mind:

Drawing details or small marks:
- Confine most movement to the fingers and wrist.
- Hold the pen firmly, but not tight.
- Hold the pen in the lower third area.
- Move the pen with a slow and steady pace.

Drawing large or gestural marks:
- Involve movement of the lower and upper arm.
- Hold the pen less firmly, but not loose.
- Hold the pen further from the point, in the mid third area.
- Move the pen with a quicker pace.

For general drawing practice, you will most likely find yourself somewhere in-between these two extremes. It is important to find a comfortable middle ground that fits your natural way of drawing and enables you to consistently produce the results you want.

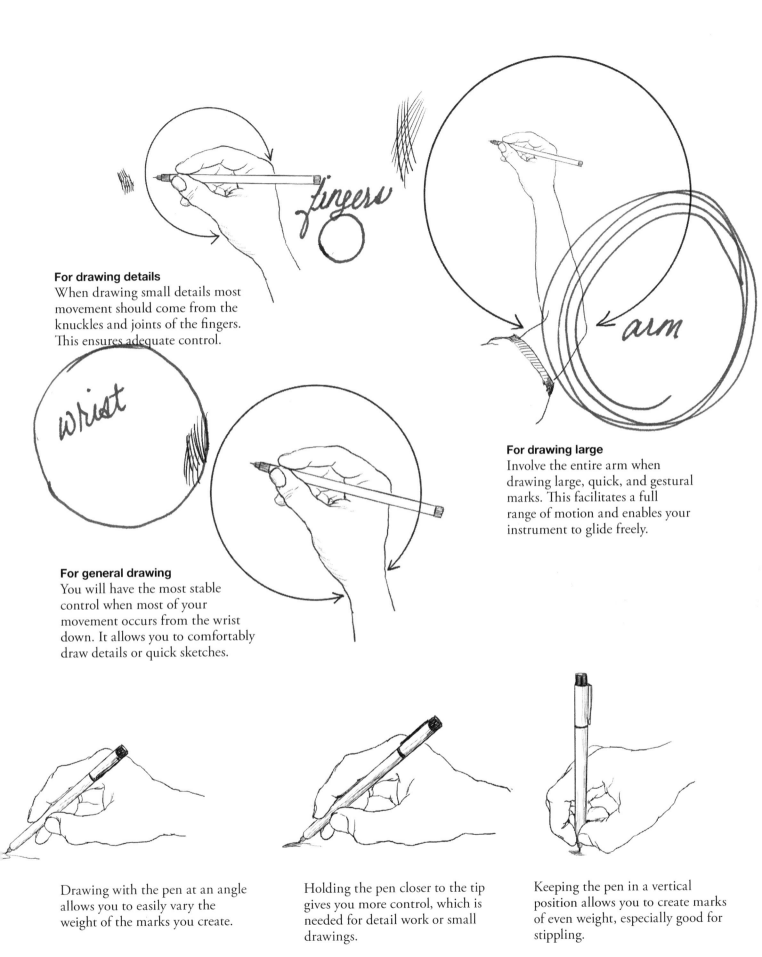

For drawing details

When drawing small details most movement should come from the knuckles and joints of the fingers. This ensures adequate control.

For general drawing

You will have the most stable control when most of your movement occurs from the wrist down. It allows you to comfortably draw details or quick sketches.

For drawing large

Involve the entire arm when drawing large, quick, and gestural marks. This facilitates a full range of motion and enables your instrument to glide freely.

Drawing with the pen at an angle allows you to easily vary the weight of the marks you create.

Holding the pen closer to the tip gives you more control, which is needed for detail work or small drawings.

Keeping the pen in a vertical position allows you to create marks of even weight, especially good for stippling.

BASIC TYPES OF STROKES

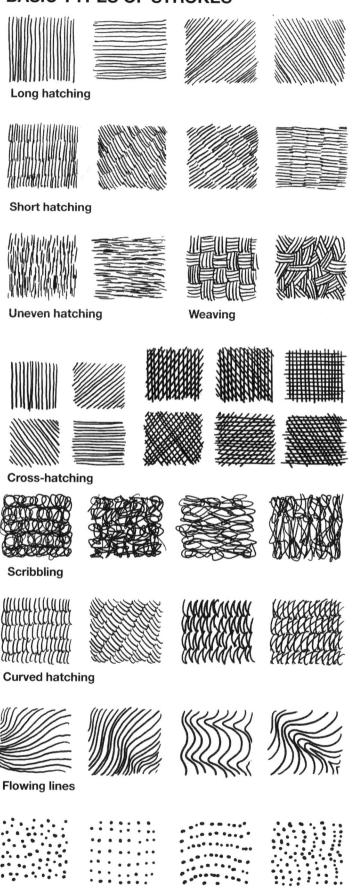

Long hatching

Short hatching

Uneven hatching **Weaving**

Cross-hatching

Scribbling

Curved hatching

Flowing lines

Stippling

These are the most common types of strokes used in ink drawing. You can vary and combine them in countless ways to create complex and extraordinary artworks. Practice them until they become a natural part of your visual language.

Always experiment

Don't limit yourself to these types of strokes only. Try out new mark-making techniques and explore new ways of using familiar strokes. Major creative breakthroughs are often achieved through experimentation and the possibilities of finding new ways to use pen and ink are endless.

Abstract Design Motifs

These are structured patterns generally used to create decorative or ornamental designs and abstract compositions.

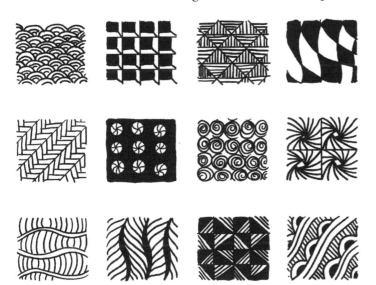

WAYS TO VARY A STROKE

Practicing ways of varying a stroke enables you to understand how various effects are created. For instance, changing a stroke's direction can convey a plane shift and describe a form's three-dimensional shape and structure. Likewise, spacing strokes can suggest a change in value or evoke a particular texture. This is the beginning of learning the key techniques that will take your ink drawing to new levels. Practice these variations individually until you're able to naturally combine them into your drawings to create the effects you want.

Five ways to vary a stroke:
- Size
- Spacing
- Layers
- Direction
- Weight

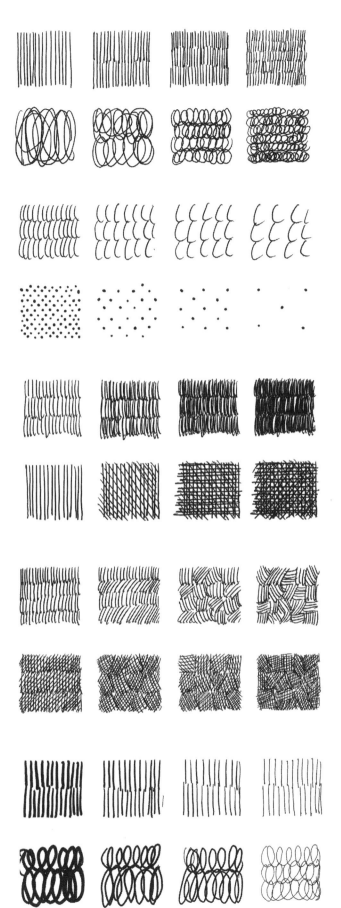

Size

The size of the marks get smaller as you move from left to right. Notice that with both examples all other aspects of the strokes remain consistent, only the size changes.

Spacing

The marks gradually get further apart from left to right. This variation is especially useful for conveying light and shadow patterns and value gradation.

Layers

You are essentially laying the same type of marks on top of each other. Note that you can either vary the direction of the marks as you add each new layer or keep it the same. You can create different visual effects with each approach.

Direction

Exciting textures and patterns can be created with this variation. It can also be an effective way to describe the cross-contour of forms.

Weight

Mass, volume, and value gradation can all be conveyed through line-weight variation. Even without any shading of interior forms, simply varying that the weight of a subject's outline can have a significant impact on its depth.

Curved hatching varied in weight, spacing, layers, and size to capture the sharp contrast in light and shadow created by the strong light as well as the texture of the hat.

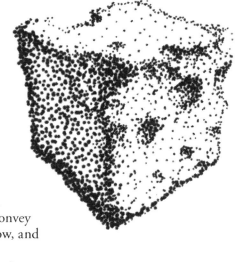

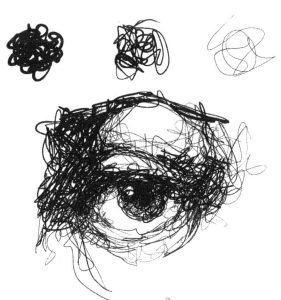

COMBINE VARIATIONS OF A STROKE

By combining the variations you begin to explore the personality of each stroke and the levels of complexity each has to offer. You can recreate light and shadow effects, sculpt forms, and convey realistic textures. When you apply the variations of a stroke, you expand the creative potential of your work.

Scribbling varied in size, spacing, layers, and weight to convey light and shadow, texture, and even the expressive quality of this drawing.

Stippling varied in size, spacing, and layers to convey texture, light and shadow, and local value.

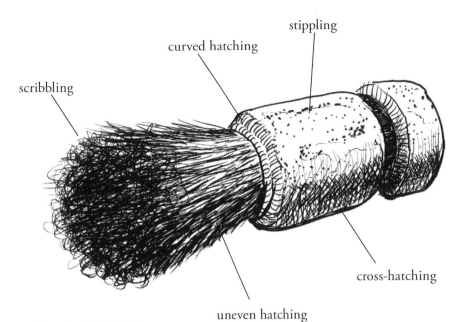

scribbling

curved hatching

stippling

cross-hatching

uneven hatching

COMBINE DIFFERENT TYPES OF STROKES

Confining yourself to only one type of stroke in a drawing can sometimes stifle your creativity. Explore the creative possibilities in using a variety of strokes in a single drawing. This often leads to more dynamic and compelling artworks.

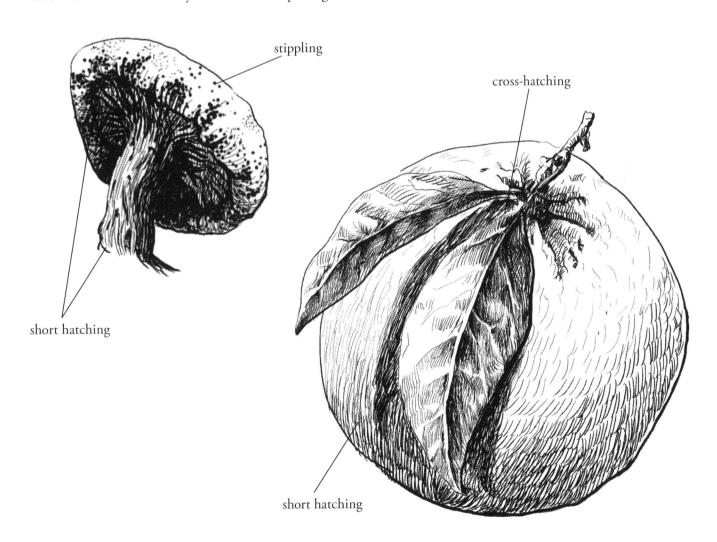

stippling

cross-hatching

short hatching

short hatching

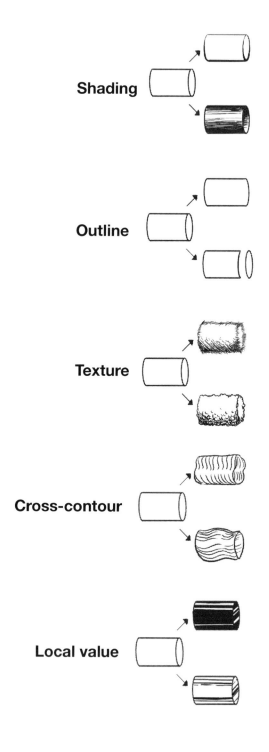

Shading

Outline

Texture

Cross-contour

Local value

WAYS TO USE A STROKE

A stroke will rarely serve only one function in a drawing. For instance, strokes used for a subject's contour will simultaneously describe its shape, texture, and even its value pattern. You may not necessarily intend to convey all four.

When you make it a habit to think about the purpose of your strokes, you become more engaged with your creative process and gain added control over your drawing's outcome. If not, your ink drawings can quickly spin out of control and you end up with unwanted results. When you are aware of, the various functions of your strokes and you will see a significant improvement in the way you approach ink drawing.

Five ways to use a stroke:
- Shading
- Outline
- Texture
- Cross-contour
- Local value

Initially, you may find it challenging to break an image apart like this because you're really separating elements that are normally perceived as a whole. But with enough practice it will become a natural part of your drawing process.

Texture
The strokes are being used primarily to indicate the texture of the eyebrow here. Other than for local value, no other function is as important here.

Shading
Here, the strokes are not only curved to follow the contour of the rounded form above the upper eyelids, but to also conform to the light and shadow pattern as well. They are sparse and short in the brightly lit area, and dense and long in the shadowed area.

Local value
You can make three clear value distinctions here: the reflections (white), pupil (black), and iris (gray).

Outline
The individual shapes of the reflections, pupil, and iris are clear and distinct. Note that the shape of the reflections are not drawn with an outline, but defined indirectly by the deeper values of the pupil and iris surrounding them.

Cross-contour
These simple curved marks are used to accentuate the round bulging mass of the lower eyelid and the forms below it. Think of them as ant trails moving across a surface or as the lines of longitude on a globe.

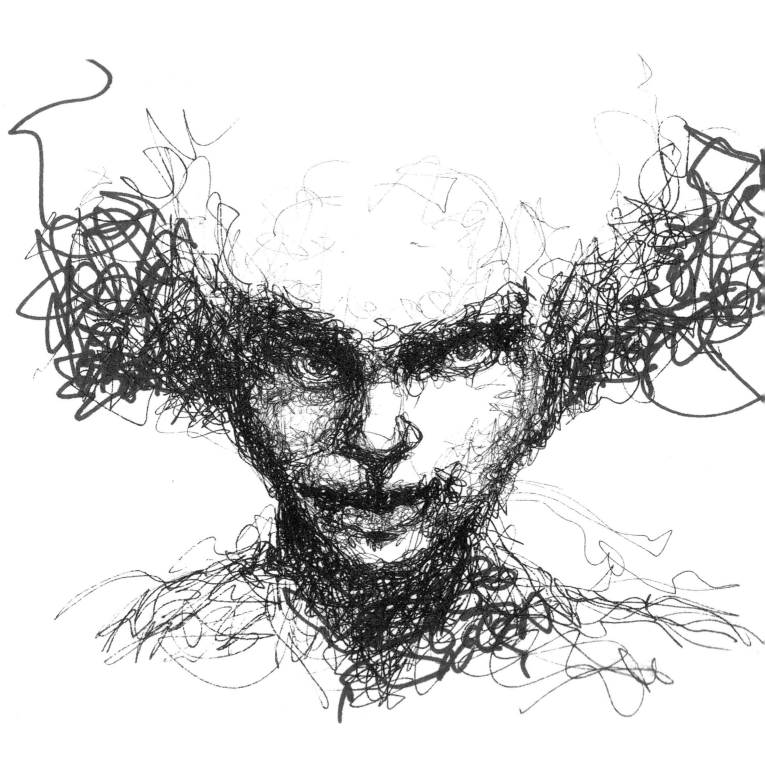

This portrait's visual impact lies in the variations used throughout the entire drawing. Control and chaos are harmonized. The erratic scribbles are controlled just enough in size, weight, and spacing to define the features and contour of the face, but remain unbridled to create a fiercely expressive countenance.

Shading

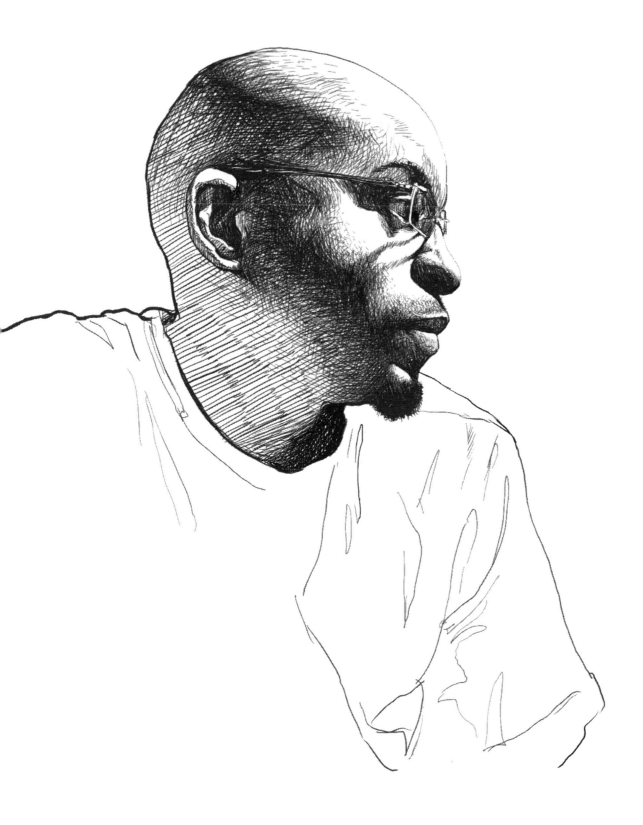

3

Most beginners find shading to be one of the most elusive and challenging aspects of ink drawing because just grasping the idea of shading with lines is challenging enough. Whether using lines or tone, a primary source of the challenge arises from not fully understanding why we shade in the first place. The main purpose of shading is to convey the volume, mass, and three-dimensional shape of forms by modeling the effects of light. This requires some understanding of values, light, and basic skills and techniques.

Three key aspects of shading:

* Values. Understand how to simplify, distinguish, and group them.
* Light. Understand how it creates value patterns and reveals the three-dimensional shape and structure of forms.
* Skills and techniques. Develop them enough to effectively execute your understanding on paper.

Values are your ABCs

As your building blocks, shading effectively requires that you learn to simplify, group, and distinguish values. However, a common misconception is believing it is necessary to represent all the values we observe in a subject. It isn't necessary, neither is it possible, to attempt to represent the infinite range of values we see. In fact, you need no more than six values to create a realistic depiction. The more you practice simplifying things in this way the less likely you will feel overwhelmed by the abundance of information reality throws at you. Remember that drawing is just a magic trick, an illusion presented on paper.

You need to see the light

Many people struggle with shading because they don't quite understand how light interacts with forms to create value patterns. Areas of light and shadow don't appear on forms arbitrarily, but follow a particular pattern depending on the nature of the lighting conditions and the shape of the lit form. Taking the time to study a subject's form and structure enables you to anticipate what type of value pattern will be created.

Hone your skills

It is good to have an understanding of light and shadow, but it is better to be able to also demonstrate this understanding on paper. Take the time to learn the basic skills and techniques of rendering. Regardless of the instrument or types of strokes you use, the core shading skills you need remain the same. In this chapter you will learn the basic aspects of value, light, and shading that will provide you with the necessary foundation to render complex subjects.

SEEING VALUES

Being able to simplify, distinguish, and group values is an integral part of the shading process. Start by practicing to see only in terms of values; areas of light and dark. See every part of the subject as having either a light, middle, or deep value. As a result, you learn to focus on major value relationships and establish a solid foundation to begin rendering.

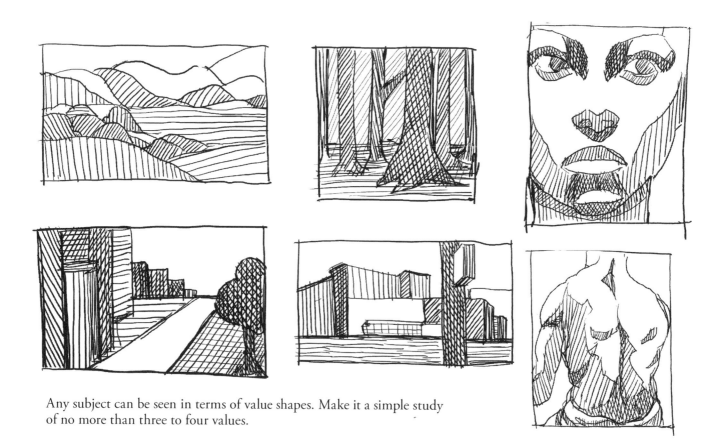

Any subject can be seen in terms of value shapes. Make it a simple study of no more than three to four values.

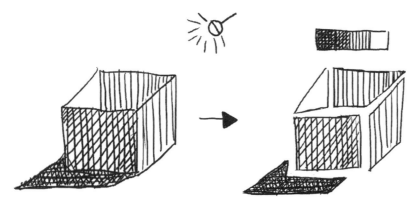

This demonstrates what happens when you see a subject in terms of its values. You not only see the box as a three-dimensional structure but as an arrangement of value shapes.

CREATING EVEN VALUE

An area of even value is called a tone. To create a tone successfully, variations like, size, weight, spacing, and layering must be kept consistent. This is evident when conveying textures, areas of light and shadow, or depicting parts of a subject with even value. Practice creating tones with different types of strokes and experiment with combining the variations. Maintaining continuity in mark-making is essential to the overall visual impact of ink drawings.

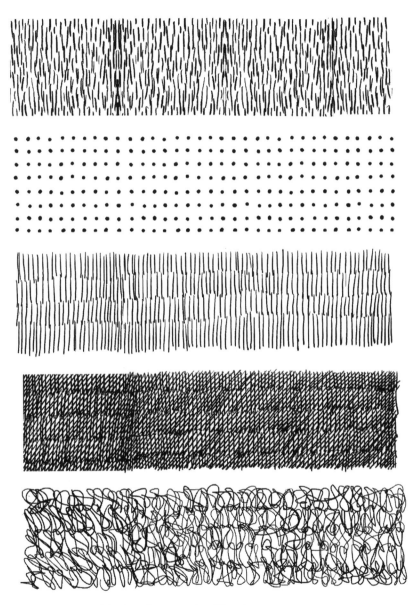

Creating blocks of even value like these is invaluable practice for learning how to control the variations of a stroke.

VALUE SCALES

One of the most effective ways to practice simplifying, grouping, and distinguishing values is by creating value scales. A value scale is a band of values ranging from black, through a series of progressively lighter grays, to white, or vice versa. Practice creating value scales using as many different types of strokes as you can. Save the ones you think you did really well and use them as references for shading. This helps you to remember the stroke variations you can apply to create the values you want.

two-step value scale

three-step value scale

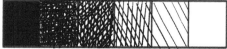

six-step value scale

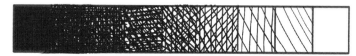

nine-step value scale

How to create a value scale

- Leave the last step blank to represent the lightest value.
- Then, apply a light layer of strokes to the remaining steps.
- Second, leave the last step of the first layer of strokes untouched and apply a second layer of strokes to the rest.
- Repeat this process until you finally shade in the first step with the deepest value.

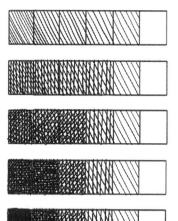

Solid and nonsolid black

Solid black can be very effective for creating bold contrast and emphasis. However, in pen and ink drawing, your deepest value doesn't always need to be a solid black. It is sometimes useful to substitute solid black with a dense layering of strokes that allows specks of white (or other background color) to show through. This can create a more pleasing harmony with other areas of the drawing done with the same types of strokes. Also, this type of nonsolid black helps to accentuate the volume of forms by suggesting the reach of light in deeply shadowed areas.

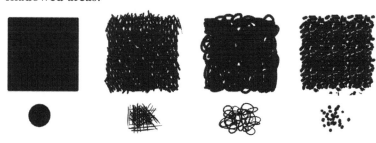

Six values are all you need

A nine-step value scale is good practice; however, six steps are all you really need for creating dynamic compositions with a full range of lights and darks. A drawing made up of six values can easily fool the eye into believing there are more values than are actually used. Six values, when dispersed throughout a drawing, can seem like nine or more when seen as a whole.

Number your values

Break up your six-step value scale into three groups of values: two deep, two middle, and two light. Label the first step, 5, to represent your deepest value. Label the next step, 4, and continue in this way until your last step, which is 0. Labelling this last step 0 is fitting since it is left untouched.

There are several ways you can incorporate this numbering system into your drawing process. In the early stages of a drawing you can start out with just two or three values as you establish a basic value pattern or make a general separation of the light and shadow areas. Then as the drawing develops, you can gradually widen your range to five or six.

Another useful way of using this numbering system, is to restrict a particular group of areas to certain values, say 1 and 2, while another group may contain only 3 and 4. Then, there may be a special area of emphasis left only for 0 and 5 because of its high contrast. This is a very useful method for mapping out and keeping track of your values as you render a subject.

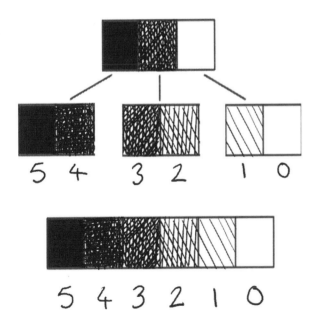

GRADATION OF VALUE

Being able to show a gradual change in value is an essential skill, and is perhaps one of the most challenging aspects of pen and ink drawing for most beginners. Among other applications, gradation is used particularly for describing the curvature of round forms. It is important to practice controlling both the rate and range of gradation, using a variety of stroke types.

Mix different types of strokes

Practice gradating values using a combination of different types of strokes. Strokes such as cross-hatching and hatching can be combined with scribbling and stippling to create smooth transitions.

Control the rate of gradation

With this exercise you learn to control the rate of gradation from dark to light. The lighting conditions and curvature of a form often largely dictates if the transition from light to dark is sharp or gradual.

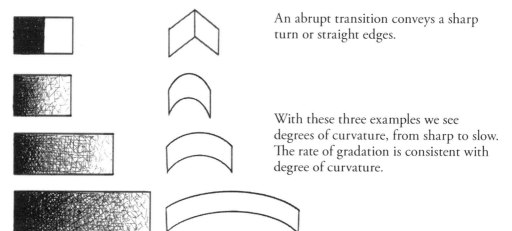

An abrupt transition conveys a sharp turn or straight edges.

With these three examples we see degrees of curvature, from sharp to slow. The rate of gradation is consistent with degree of curvature.

Control the range of gradation

From this exercise you learn to control the starting and ending values of gradation. This is important for maintaining the overall value of an area or part of a form. For instance, in light areas, gradation will occur between light values only. And in areas of shadow, gradation will be restricted to deep values. Controlling the range of gradation enables you to preserve the integrity of value and lighting of the respective parts of a drawing or form.

deep to deep

deep to light

mid value to light

deep to mid value

mid value to mid value

light to light

Diverge and converge gradation

When shading round forms gradation will not just occur in one direction as in the preceding exercises. Gradation will often be multidirectional, and this exercise teaches you to do just that.

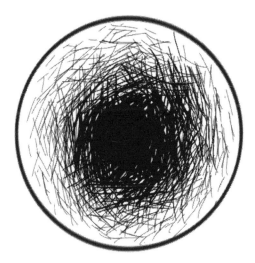

Gradate values radially from a small black center towards the outline of the circle. Try to fade the black into the white of the paper before reaching the outline.

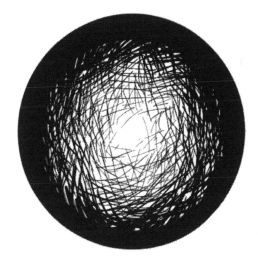

In contrast, gradate values inward from the outline of the circle towards the center. And this time, fade the black into the white of the paper before reaching the center.

The direction of the lines reinforce the shape and structure of the forms, while planes remain equivalent in value.

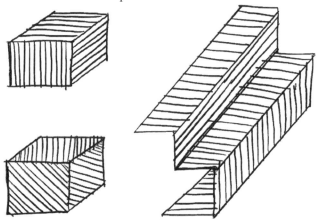

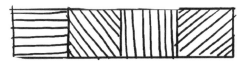

Each band of strokes has the same value and pattern but the changes in direction create individual structural and textural suggestions.

VALUE CONTROL

Drawing with line allow you to describe the shape and structure of forms while maintaining little change in value. The emphasis here is not to represent light and shadow, but to describe cross-contour. The key is to maintain overall consistency and vary only the direction of the strokes.

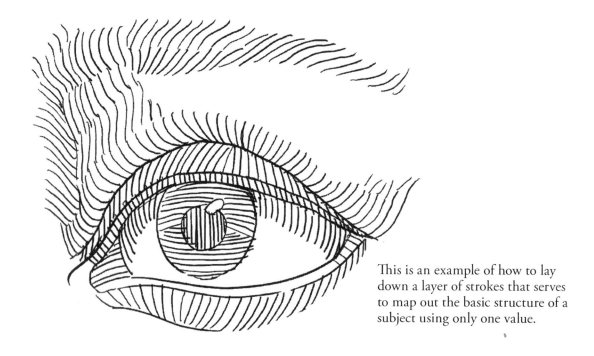

This is an example of how to lay down a layer of strokes that serves to map out the basic structure of a subject using only one value.

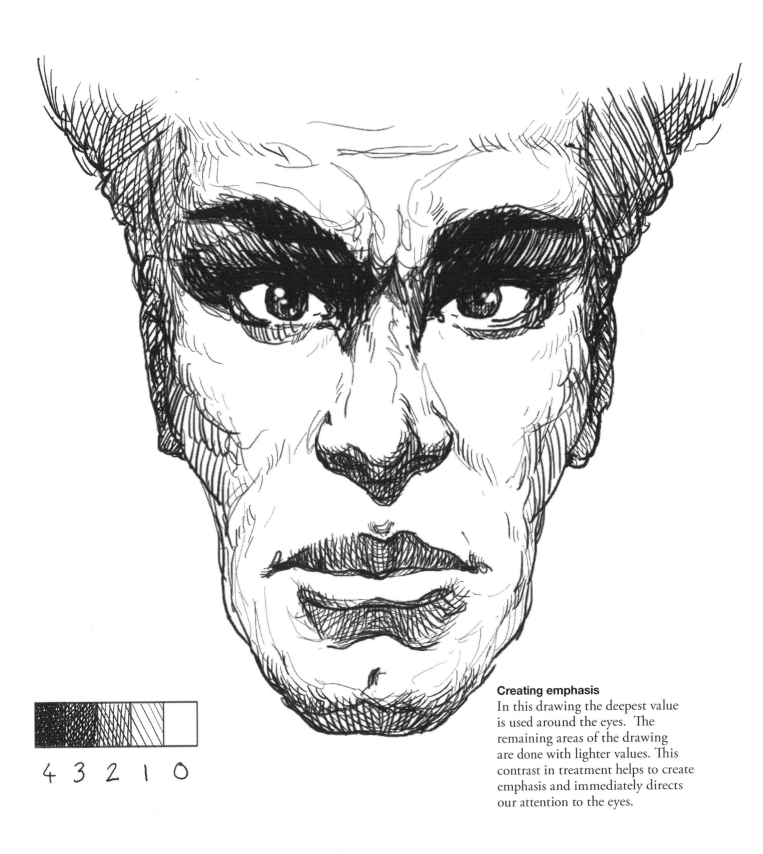

4 3 2 1 0

Creating emphasis
In this drawing the deepest value is used around the eyes. The remaining areas of the drawing are done with lighter values. This contrast in treatment helps to create emphasis and immediately directs our attention to the eyes.

LOCAL VALUE

Local value refers to the inherent value of an object. In pen and ink drawing, colors should be seen as shades of gray. This means a green banana would be represented as a deeper gray than one that's yellow, because green is inherently darker than yellow.

Also, the lighting conditions of an object can alter how light or deep in value it appears to you. At different distances to the light source or under different lighting intensities the same object can appear to have different values.

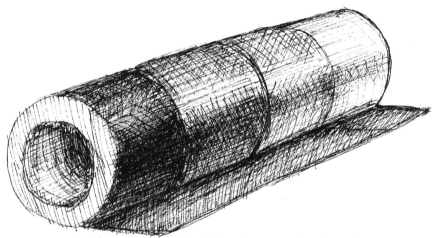

Each band on this cylindrical form has a different local value. However, notice that the overall value pattern is consistent for the entire form.

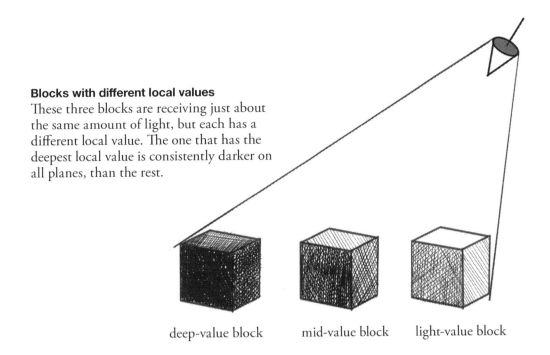

Blocks with different local values

These three blocks are receiving just about the same amount of light, but each has a different local value. The one that has the deepest local value is consistently darker on all planes, than the rest.

deep-value block mid-value block light-value block

One block under different lighting conditions

A block can appear lighter or deeper in value depending on the amount of light it receives. Under a dim light it will appear darker than its true local value. Conversely, a bright light will make it appear lighter.

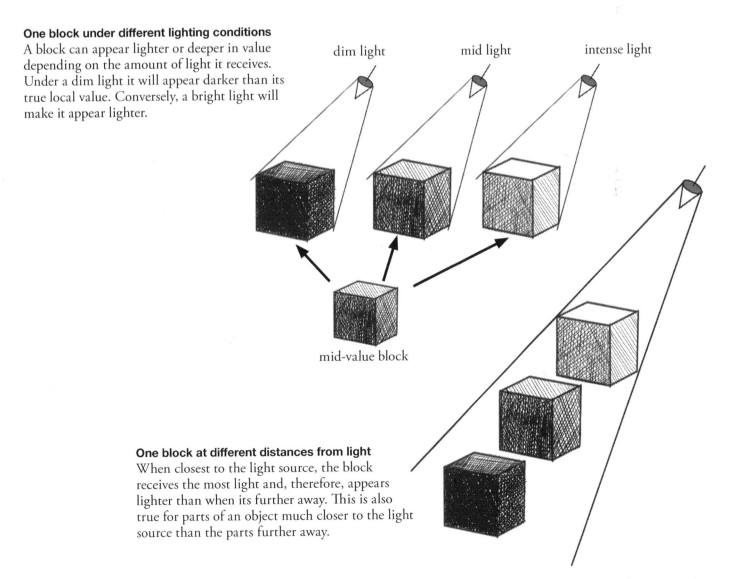

dim light mid light intense light

mid-value block

One block at different distances from light

When closest to the light source, the block receives the most light and, therefore, appears lighter than when its further away. This is also true for parts of an object much closer to the light source than the parts further away.

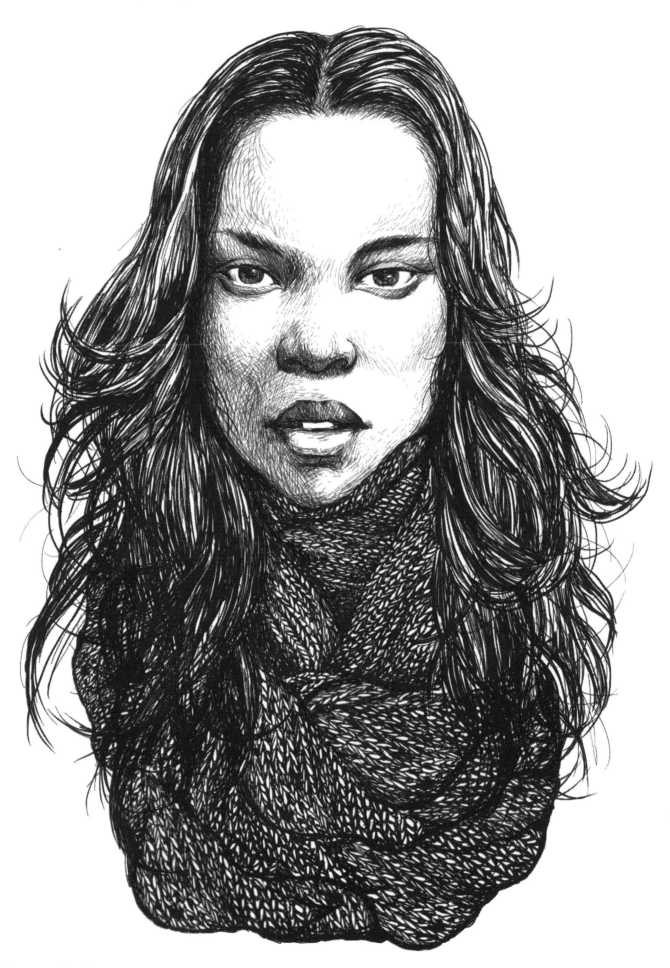

Note the control of the range of values used in the various areas of this portrait. Her hair and scarf have a deep local value, which is maintained in both areas of light and shadow. The hair and scarf are used to frame the face, which has a lighter local value. The value range of the face is controlled so that, even in areas of shadow, like on the left, the values are still kept light enough to distinguish that area from the deeper values of the surrounding hair and scarf.

STRUCTURE AND SHADING

Every three-dimensional object has six basic sides: front, back, top, bottom, left, and right. These six sides arise from the three planes of space and enable us to accurately define volume and position. It is easier to model forms to appear three-dimensional when you're able to see and distinguish these basic sides. This is convenient for block forms with their flat sides and straight edges, but can be challenging for round forms. With round forms, it helps to reduce or visualize them in terms of simple block-like structures with flat planes and straight edges. This makes rendering round forms a much less daunting task.

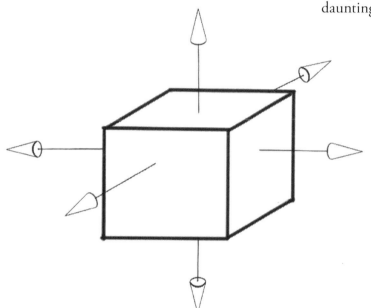

The six basic sides
All three-dimensional forms have a front, back, top, bottom, left, and right side. Practice visualizing them when modelling forms.

There is an increase in volume conveyed as we move from left to right. The more of the basic sides we can see and distinguish, the more volume we perceive.

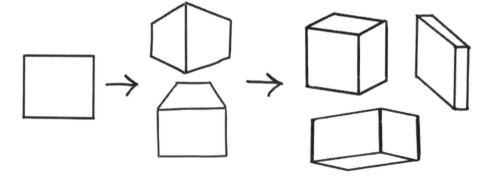

Thinking of round forms as having six basic sides makes it easier to convey their volume.

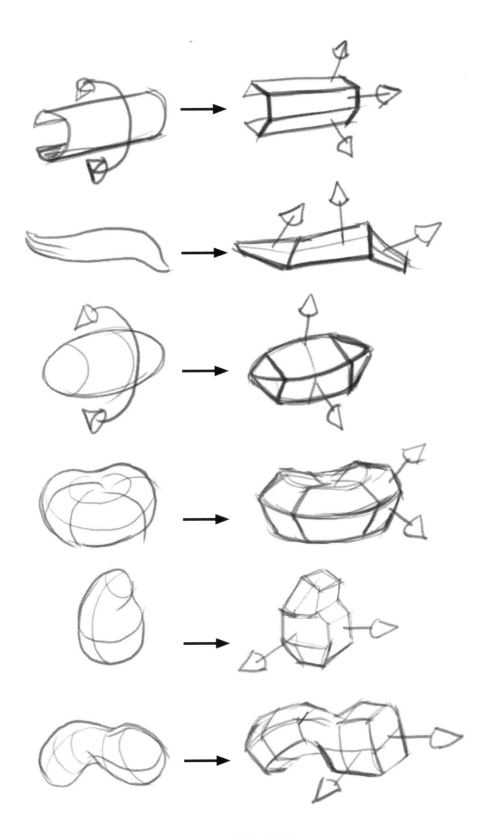

Reduce rounded forms to block forms

Make it a part of your drawing process to think of and visualize round forms in this way. It will significantly simplify the shading for you.

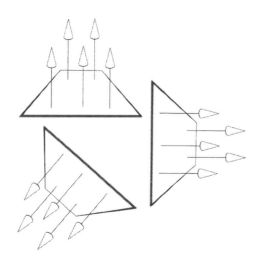

All points on a flat surface face the same direction.

START YOUR SHADING WITH SIMPLE FORMS

Before tackling complex subjects, it is best to first learn how to render simple forms such as, the block, sphere, cylinder, egg, and so on. Their value patterns are simple and understanding how light and shadow defines their shape and structure is much easier to grasp.

Shading a block

The block has the simplest value pattern of the simple forms because of its flat sides and straight edges. The key to shading a block is to determine the orientation of the basic sides in relation to the light source, then assign them their respective values. And since all points on a flat surface share the same orientation, it is safe to assign one even value to each side. This simplifies rendering even the most complex forms.

The three-value method

The side most directly facing the light source is assigned the lightest value. The side most facing away will have the deepest value, and the side in that is somewhat in-between will have a middle value.

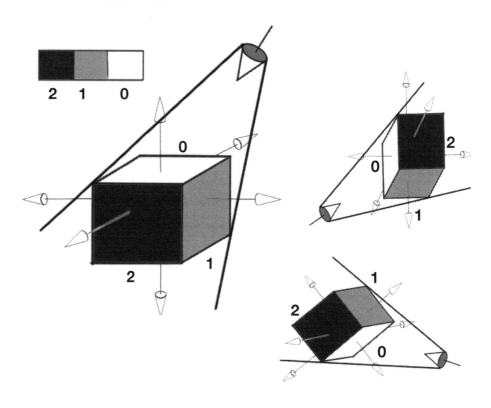

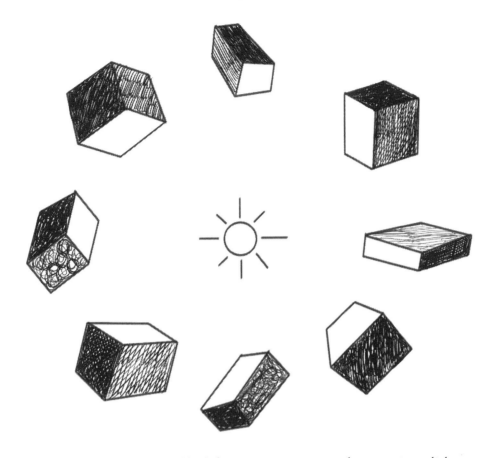

Draw as many simple block forms as you can around an imaginary light source and shade them based on the orientation of the sides to the light source.

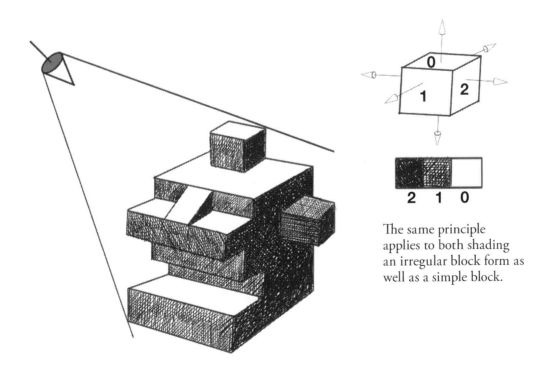

The same principle applies to both shading an irregular block form as well as a simple block.

SHADING ROUND FORMS

Unlike block forms, round forms have a curving surface and require gradation to define their three-dimensional shape. When you find it difficult to see their curvature, use cross-contour lines to guide your shading. Simple forms like the sphere and cylinder are perfect models to develop your practice before moving on to complex subjects.

Key concepts to shading round forms:

- The curving surface of a round form creates a gradual turn away from light. This results in a smooth transition between areas in light and areas in shadow.
- The part most directly facing the light source will have the lightest value. Values will gradually deepen as the surface turns away from the light and into shadow.
- Values in light areas should always be consistently lighter than values in shadow areas of the same form.

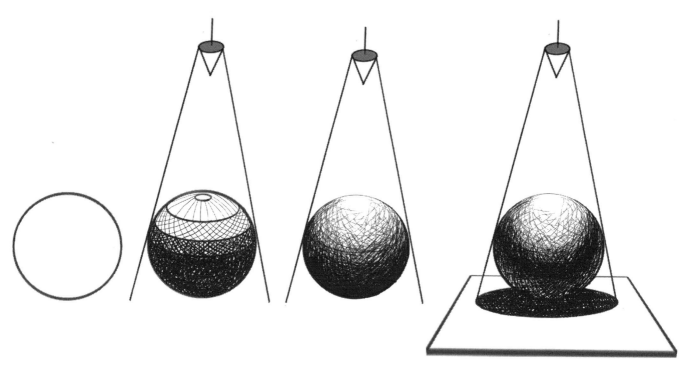

Without light there is no perception of depth or volume. We don't perceive a sphere, only a flat shape.

A step-wise gradation showing the transition from light to dark when a round form is lit from above.

Value gradates smoothly from light to dark, and areas in shadow remain obscure.

With light bouncing from the surface below, the areas in shadow are now illuminated. As a result, the mass, volume, and sense of space of the sphere are more strongly felt.

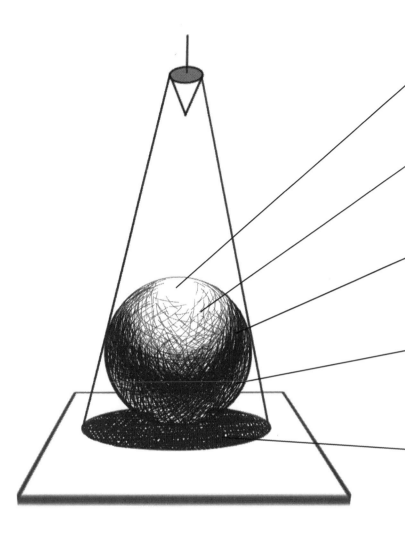

The value pattern of a round form

The bright spot
The part of the form most directly facing the light source, and lightest in value.

Middle value area
The part of the form in light but not directly facing the light source. Most areas in light will be of middle value. This part gradually gets deeper in value as it approaches the shadow border.

Shadow border
This is the part of the form where the areas in shadow begin. The shadow border blends into the light area on one side and the reflected light area on the other.

Reflected light area
This part of the form is in shadow but is partly illuminated by light bouncing off surrounding surfaces. Note that it is not as brightly lit as areas lit directly by the light source.

Cast shadow
This is a shadow formed from the sphere blocking light from the surface below. Cast shadows can be useful for describing the position of a form in relation its surroundings. Sometimes they help to describe the shape of the object they fall on.

shadow border

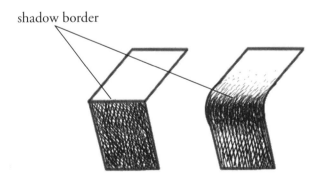

Think of the shadow border as the "edge" of round forms. It marks where the shadow areas begin. In contrast to block forms, the transition into shadow is smooth.

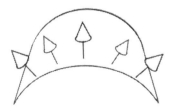

Points across a curving surface receive different amounts of light. This results in a gradation in value.

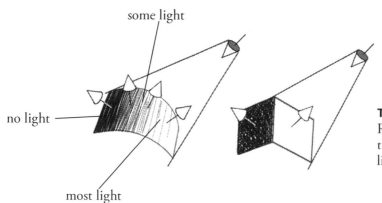

some light

no light

most light

The shadow border marks the end of light
Round forms turn into shadow gradually, and the shadow border occurs where the reach of light ends completely.

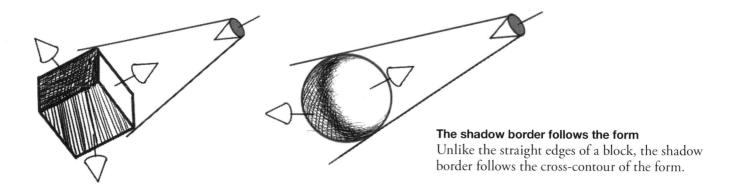

The shadow border follows the form
Unlike the straight edges of a block, the shadow border follows the cross-contour of the form.

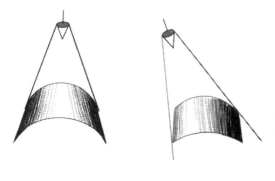

The shadow border follows the light
Unlike the fixed edge of a block, the shadow border moves with the light source.

thin narrow wide

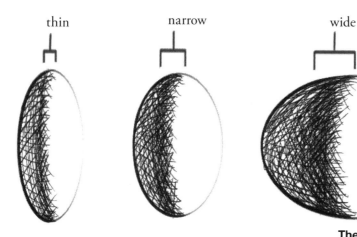

The shadow border's shape changes with the form
The width of the shadow border is consistent with the curvature of the form. It is thin when the form has a sharp curve, and widens as the curve gets more gradual.

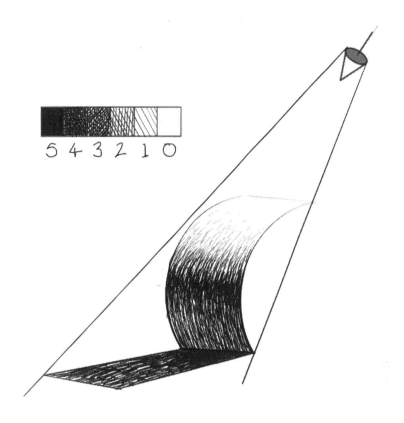

THE SIX-VALUE METHOD

Depicting the curvature of round forms can be done
effectively with just six values. Three values for the light areas,
and three for the areas in shadow. The lightest value is used
for the part of the form most directly facing the light source.
The deepest value is used for the cast shadow. However, the
deepest value *on* the form is used for the shadow border.
Again, note that the reflected light area is not as light in value
as the areas being lit directly.

light area values

shadow area values

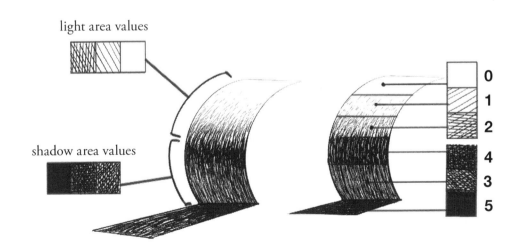

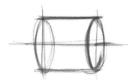

APPLY SHADING IN LAYERS

Given the unforgiving nature of ink it helps to apply shading in layers. This approach also allows you to see the progress of the drawing as it develops and keep track of important value relationships.

Think of the three-dimensional shape and structure of the form before you begin rendering. This helps to determine the direction of your strokes.

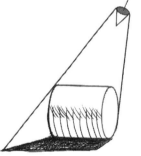

You should have a clear idea of where areas of light and shadow meet. The dotted line is used here just to indicate the position of the shadow border.

The shadow border separates the areas in light from the areas in shadow and merges softly into both areas.

After you have established the basic value pattern, the areas can then be deepened by adding more layers of strokes. Use light, thin lines for areas in light, and deep, bold lines for areas in shadow.

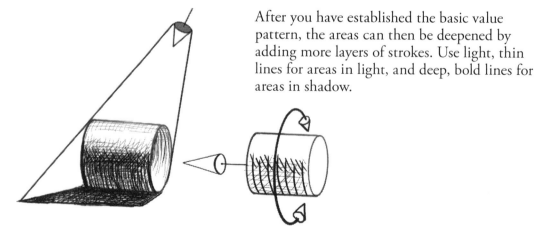

Study the value pattern

Always visualize the value pattern of a form before you begin rendering. Sketch a little diagram like this to use as a visual reference to follow.

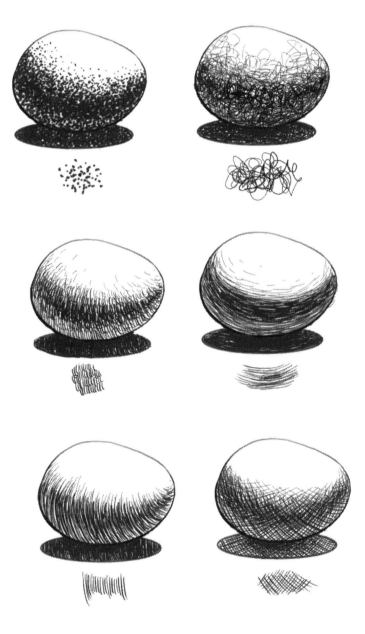

RENDER WITH DIFFERENT STROKES

Challenge yourself to render the same form with as many different types of strokes as you can. Experiment with all the stroke variations in order to create a full range of value. Not only is this good practice, but also an effective way to learn the strengths and limitations of various types of strokes.

Regardless of the strokes you use to render your subject, the key principles of shading should be consistent. In this study of the Belvedere Torso, the strokes are used to accentuate the structure and cross-contour of the forms by their directional flow and gradation in value. You can sense and distinguish the basic sides of the major masses.

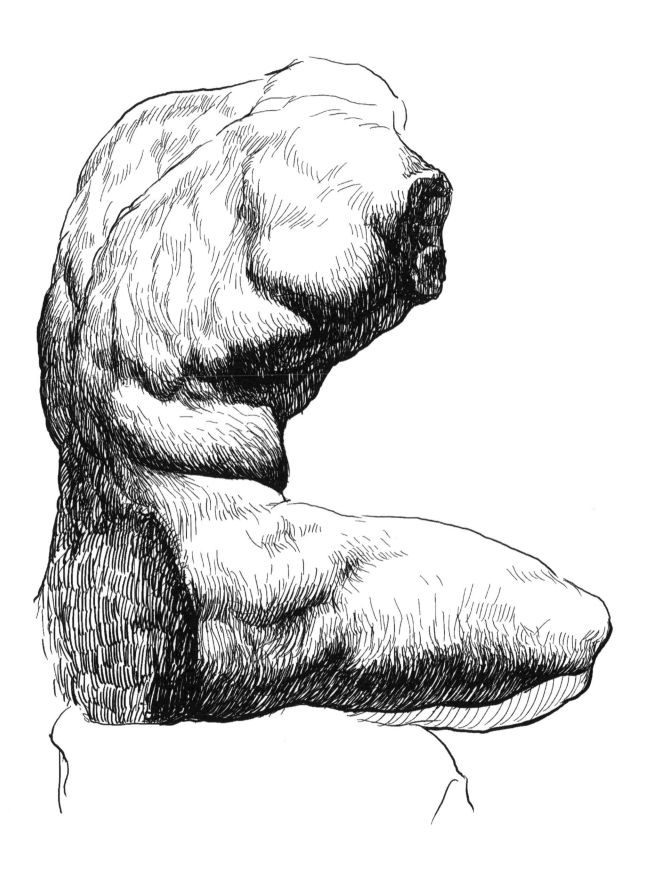

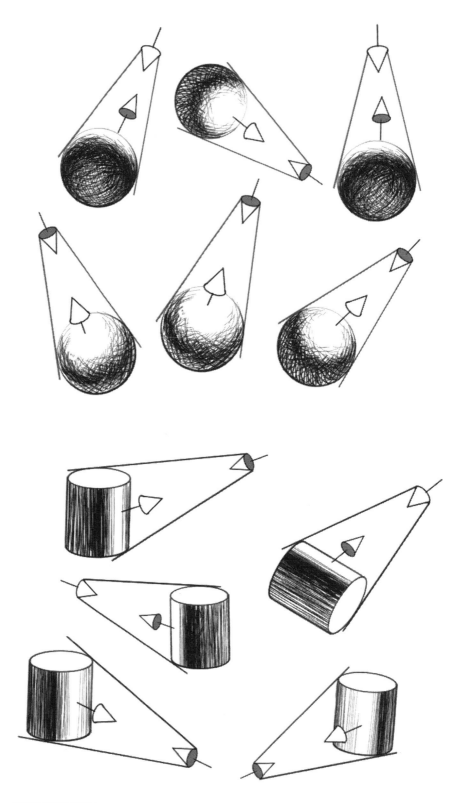

EXERCISE

Drawing spheres and cylinders in different positions and receiving light from various directions is invaluable practice for shading. Note that the shadow border is consistent with the form in relation to the light source. This exercise is best done from life, but drawing from reference photos is also very good practice.

FIVE TIPS FOR SHADING WITH LINES

1. **Keep strokes consistent** Strokes that describe a form's shape and structure should be consistent so they are read as a group with the same function.
2. **Visualize ant trails** Imagine paths of cross-contour lines going across the form
3. **Follow the form** Use strokes that follow and accentuate the three-dimensional shape and orientation of the form they describe.
4. **Less is more** Suggestion is sometimes more effective than a direct statement. You don't have to draw everything you observe. Engage the viewers imagination and use implied lines.
5. **Follow the light** Vary strokes according to the value pattern of the form. Use thin strokes to model parts of the form in light, and use bold strokes for shadow areas.

The cross-contour lines of round forms should be curved to follow their volume. Straight lines flatten form, so be careful how you use them.

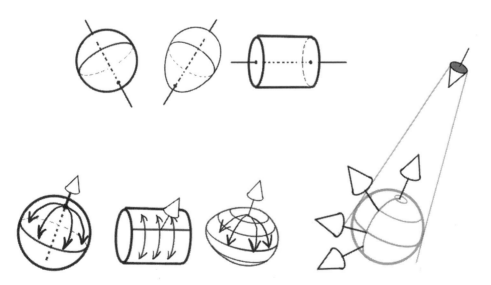

Draw strokes like lines of latitude flowing over the surface of the form.

KEEP STROKES CONSISTENT

There are four major aspects of consistency when shading with lines:

- spacing
- weight
- sizing
- direction

The consistency of your strokes depends largely on the uniformity of these four elements. Maintaining this uniformity is key to the overall visual impact of your shading and ensures the function of your strokes is read clearly.

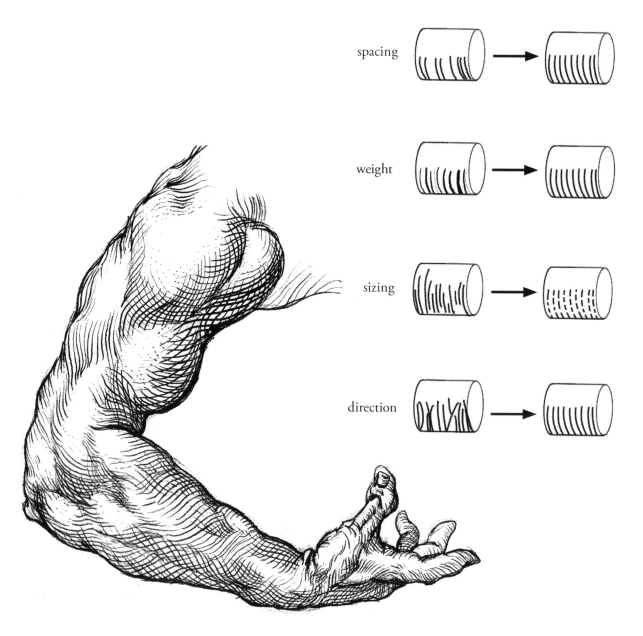

spacing

weight

sizing

direction

The strokes used to render this arm shows consistency in size, direction, spacing, and weight.

ACCENTUATE THE FORM

Your strokes should enhance the volume, mass, and structure of the form, not undermine them. Think of the form as a globe and your strokes are various lines of longitude and latitude wrapping around its surface.

Envisioning a form's line of axis will help you to sense its volume and structure as you lay down your strokes.

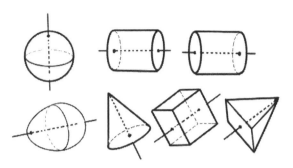

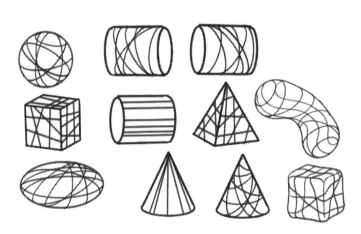

Let the direction of your strokes accentuate the volume and orientation of the form it describes.

Don't do this!
These are examples of strokes that undermine the volume of the form, rather than accentuate it. This is obviously what not to do when trying to convey depth.

PRACTICE SIMPLE RENDERING

Fill pages with drawings like these. Note that in these examples, there is only concern for distinguishing areas of light from shadow. There is no polished rendering or subtle gradation in value. Do this exercise with a wide variety of forms including round, block, concave, convex, tubular, cylindrical, and other types of forms.

WEIGHT VARIATION AND DEPTH

By varying the weight of a line you not only make it more dynamic and expressive, but you also enable it to suggest light and shadow, depth, and mass. Some ink drawing instruments are designed particularly for creating this type of stroke variation.

Practice these types of lines and explore the suggestions they create.

The thin lines suggest a lightening in value as the form approaches the light source. The bold lines convey shadow. Together they convey mass and volume.

These strokes not only describe the cross-contour of the forms, but their variation in weight also suggests light and shadow, and mass.

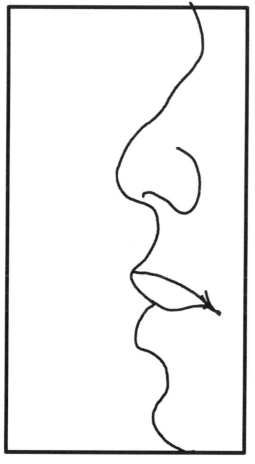

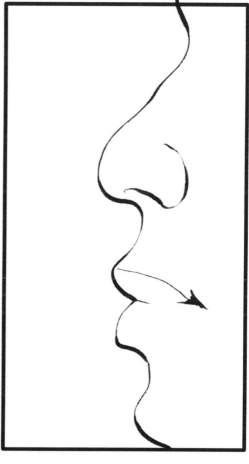

No weight variation
This profile appears flat from having no weight variation in its contours. Not much is done for conveying depth and volume.

With weight variation
The variation in weight makes this profile more dynamic and effectively conveys the mass and volume of the features.

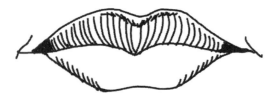

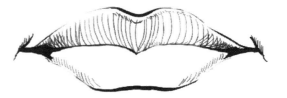

No weight variation
These lips appear flat and cartoon-like due to the uniformity of the strokes and their sealed outline. Little depth or volume is conveyed.

With weight variation
These lips appear more lifelike because of the depth, mass, and volume conveyed. Their broken contour makes their forms appear open and a part of the surrounding mass of the face.

SHADING COMPLEX FORMS

The structure of most subjects you draw will not appear to have the basic structure of a block, sphere, cylinder, or other simple forms. With practice you can learn to simplify the structure of any subject you draw to simple manageable forms.

For example, shading a book or box is no different from shading a block. A cylinder, finger, or tree trunk requires essentially the same structural approach. Visualize complex structures in terms of simple geometric shapes and your construction and shading will be so much easier.

Two ways to approach rendering complex forms:
- Merge small surface forms into a larger underlying mass
- Carve a complex form a large simple form

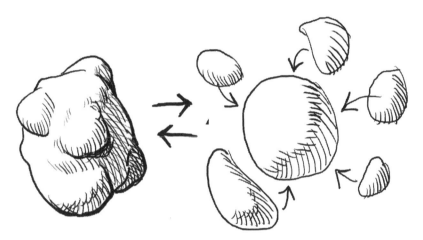

Merge major and minor forms together
This approach simplifies the process of rendering complex forms by enabling you to see small surface forms as partially submerged into a larger underlying mass. You become less distracted by the clutter of superficial details and focus instead on the structure of the dominant form underneath.

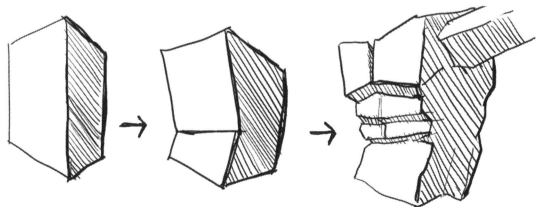

Carve a complex form out of a simple one
In this approach, the subject is constructed from a simple mass, whose basic structure is still preserved in the final rendering. In the example above, the torso still retains the basic planes of the initial block.

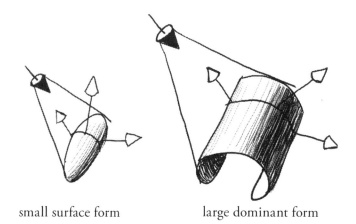

small surface form large dominant form

Small surface forms follow the dominant form

The value pattern of the small surface forms is dictated by the larger dominant form underneath. For instance, if the head is lit so that the front is in light and the side in shadow, then the ear on that side must also be in shadow. The ear is a minor form atop the dominant mass of the head. This also means the value range of the ear must correspond to the value range of that side of the head.

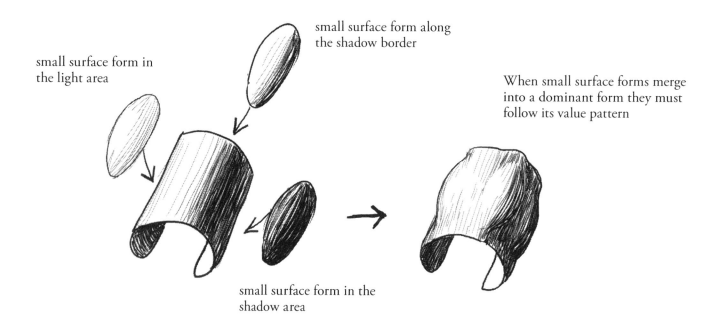

small surface form along
the shadow border

small surface form in
the light area

When small surface forms merge
into a dominant form they must
follow its value pattern

small surface form in the
shadow area

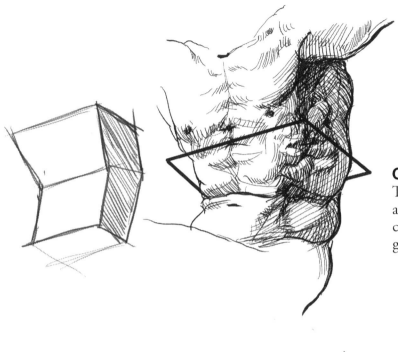

Carving out complex forms

This torso was first conceived as a block, and then the details were carved out until the natural form gradually emerged.

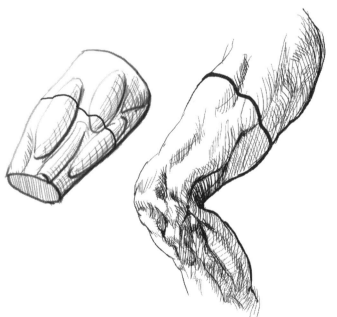

Merging large and small

This thigh was first conceived as a cylindrical mass before the muscular surface forms added to give it a natural appearance.

RENDER FROM SIMPLE TO COMPLEX

To achieve an adequate system for rendering, combine the approach of shading in stages and developing a subject from simple to complex forms. Practice this process with as many subjects as possible.

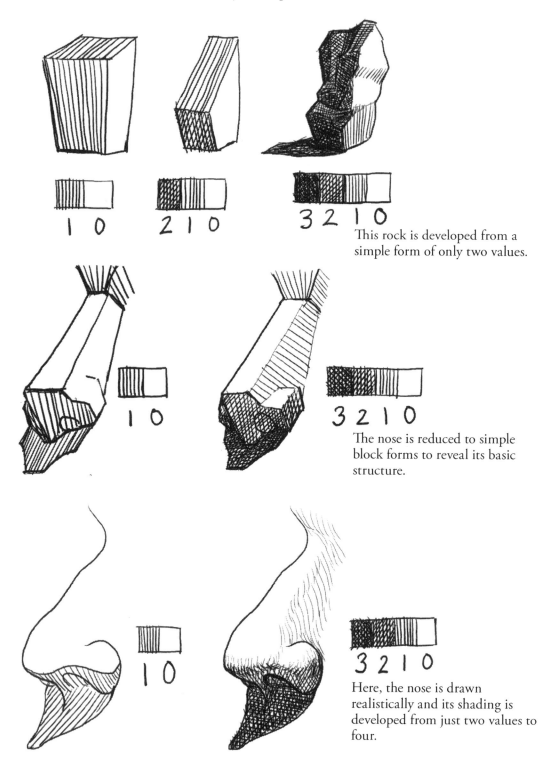

This rock is developed from a simple form of only two values.

The nose is reduced to simple block forms to reveal its basic structure.

Here, the nose is drawn realistically and its shading is developed from just two values to four.

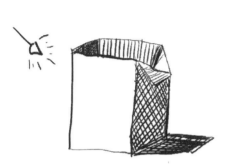

Reduce it to a simple form.

To simplify the value range focus only on separating areas in light from areas in shadow.

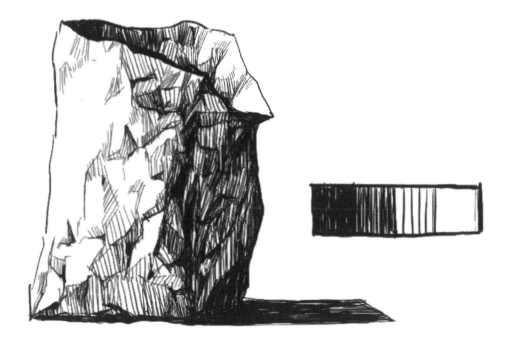

CRUMPLED PAPERBAG

Render this paper bag by first simplifying its structure to a simple form. Gradually develop the shading in stages from two or three values to a wider range of four or more.

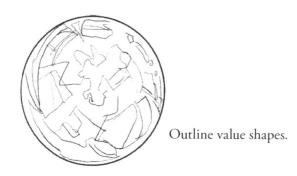

Outline value shapes.

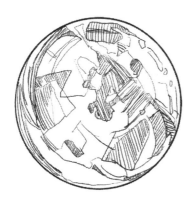

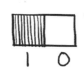

Only two values are used to establish the value pattern and distinguish the areas in white from deeper values.

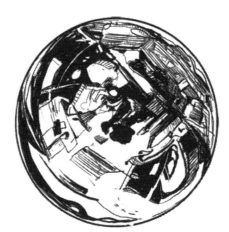

CHROME BALL

Your drawing should start with a general outline of the various value shapes and proceed to gradually expand the values and refine their shapes. The key to drawing reflective and metallic textures is to see them as an arrangement of abstract value shapes.

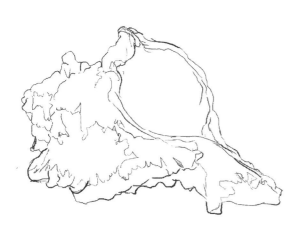

Outline its contour and the borders of shadows.

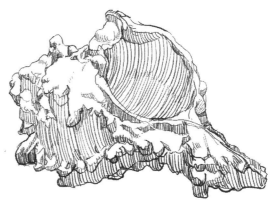

Areas in light and shadow separated using two values.

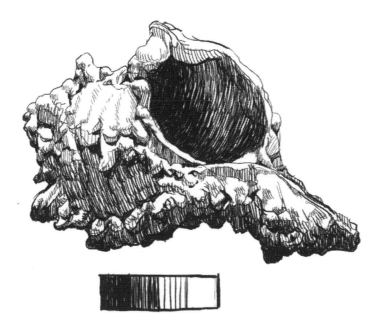

SEASHELL

Start by ignoring the smaller surface forms and focus on the dominant mass that dictates the overall value pattern. As you establish the separation of light and shadow areas, rendering the smaller surface forms falls easily into place.

Simulating Texture

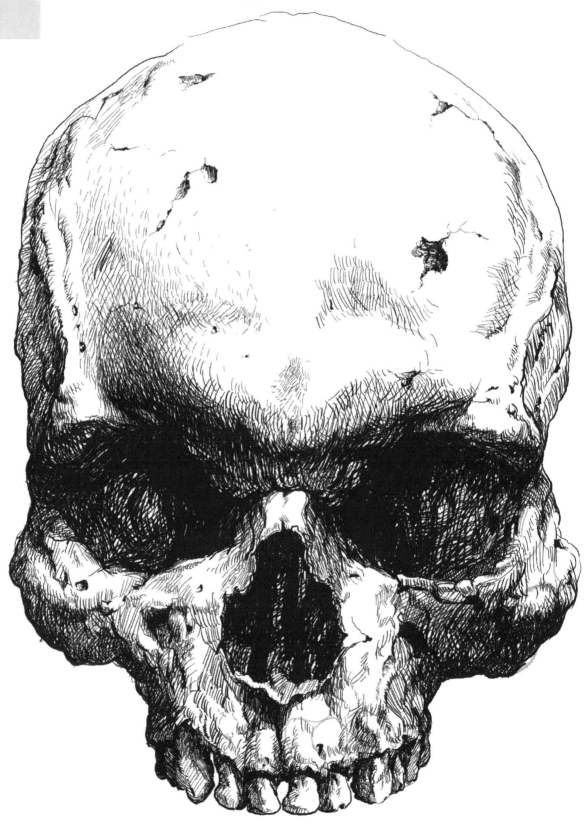

4

The fact that pen and ink is a linear medium lends itself well to creating dynamic textures. Virtually any pattern of strokes will convey some form of textural quality. However, creating striking textures involves more than just laying down a pattern of strokes, and should not be seen as an isolated activity. Instead, depicting a form's texture should be assimilated into modelling its volume and accentuating its structure. It should be seen as the form's second skin.

But making this all happen in your drawings comes down to your command of the strokes you use. Learn all you can about their properties and try to find ways to work around their limitations. Here are some tips that will help in developing your skill with creating textures:

- **Experiment with mark-making.** Don't limit yourself to just hatching, stippling, or scribbling. Try different ways to create, vary, and combine your strokes. Push your variations to extremes and see what happens. Also, study the works of artists you admire and try to recreate their effects using different approaches. Even the patterns of nature can be a great resource. Animals, plants, rocks, water, clouds, and other natural sources of inspiration around you are endless.

- **Experiment with instruments.** Step outside the box and use things you have never thought of using before. A toothbrush is a wonderful tool for creating splatter or stipples. Fabric, small rocks and even leaves can be used to add an unusual touch to your drawings.

- **Create one texture with different types of strokes.** This will push your ability to be versatile and well-rounded while also exploring the pros and cons of different types of strokes. Use what you learn as a reference guide for future drawings.

- **Create different textures with one type of stroke.** Do this especially for the types of strokes you use the most. It will challenge your ability to vary them in as many subtle ways as possible to create a wide variety of effects.

Depicting texture presents a unique challenge in drawing because it naturally affects all the other aspects of the subject. Light and shadow, mass, structure, surface details, and contour are all conveyed through this element.

CREATE A TEXTURE REFERENCE CHART

As you observe your environment take note of various textures you see and think of what techniques you could use to create them. A simple variation in your strokes can result in a totally different texture. Combine patterns and stroke variations, instruments, and techniques to come up with as many textures as you can. Keep a reference chart for textures and tips on how to recreate them, if necessary.

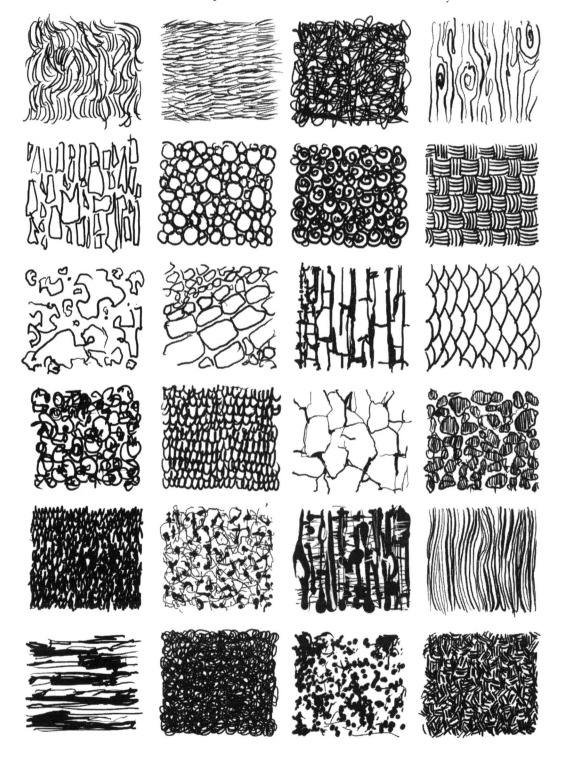

REALISTIC TEXTURE

Textures in lifelike depictions involves more than just covering an area with a pattern of strokes. Think of texture as the "skin" of the form, curving around it like skin does over the structure of the body.

Three key elements for creating realistic texture:

- Keep strokes consistent, but incorporate some variety.
- Let the texture define the form's contour.
- Use the power of suggestion. Less is more.

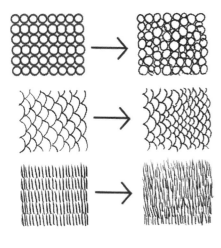

Variety adds interest

Although there is a distinct structure to the patterns of natural textures, you can still find some variety within them. The disparities, however, are not enough to disrupt the overall continuity of the pattern.

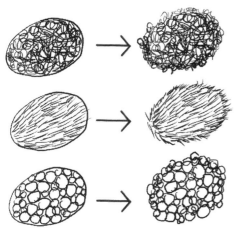

Texturize the outline

A common mistake by beginners is to enclose the texture of forms with bold outlines which makes them appear as flat shapes. Use the form's texture to define its outline.

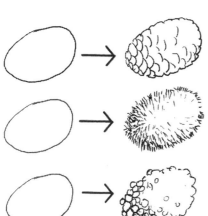

Less is more

It isn't always necessary to draw everything you see, exactly as you see it. Exploit the power of suggestion and leave some work for the viewer's imagination. It makes your drawings more engaging and also accounts for the natural effects of light and shadow.

TEXTURE FOLLOWS FORM

Think of the stripes of a zebra and how they help to define its shape and volume. A texture should follow the cross-contour of a form in a similar way. So, adjust the direction your strokes to convey the curvature of the underlying mass. Not doing this can result in what looks like just a flat shape covered with a pattern.

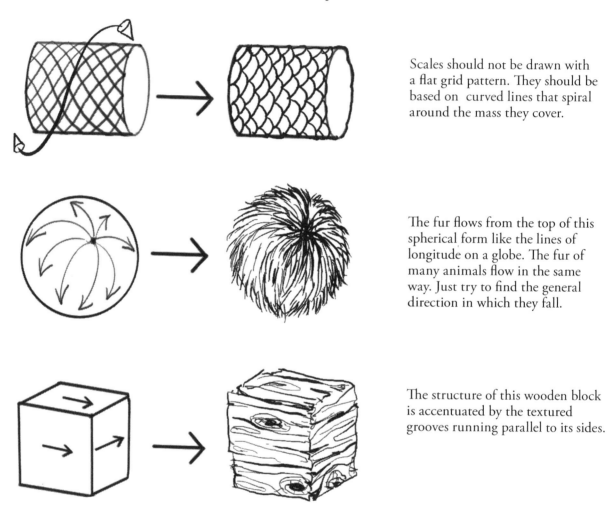

Scales should not be drawn with a flat grid pattern. They should be based on curved lines that spiral around the mass they cover.

The fur flows from the top of this spherical form like the lines of longitude on a globe. The fur of many animals flow in the same way. Just try to find the general direction in which they fall.

The structure of this wooden block is accentuated by the textured grooves running parallel to its sides.

Practice visualizing cross-contour lines and the line of axis in forms you draw. It will eventually become a natural part of your drawing process.

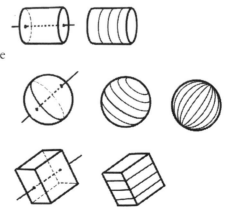

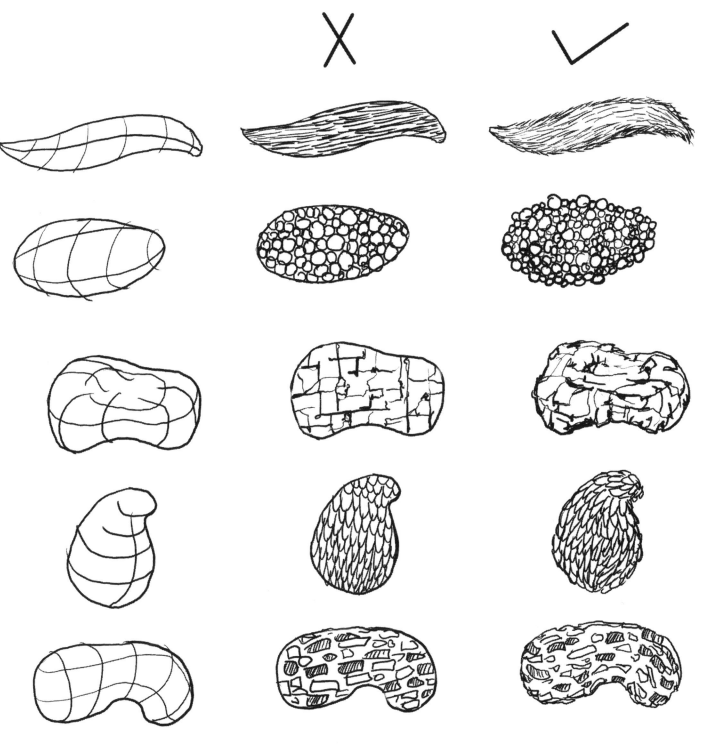

It helps to visualize a form's shape and volume by using cross-contour lines.

Here, the texture does not follow cross-contour or reinforce the volume of the form. The outline is also not defined by the texture.

The texture now wraps around the form and follows its cross-contour. It is also used to define the form's contour.

TEXTURE FOLLOWS LIGHT AND SHADOW

Thinking of a form's texture as its second skin enables you to understand how light and shadow will affect its appearance. The texture will appear lighter and sometimes bleached out on parts of the form in light, and deeper and less distinct in areas of shadow. Essentially, the value pattern created by the form's structure will be conveyed by the texture.

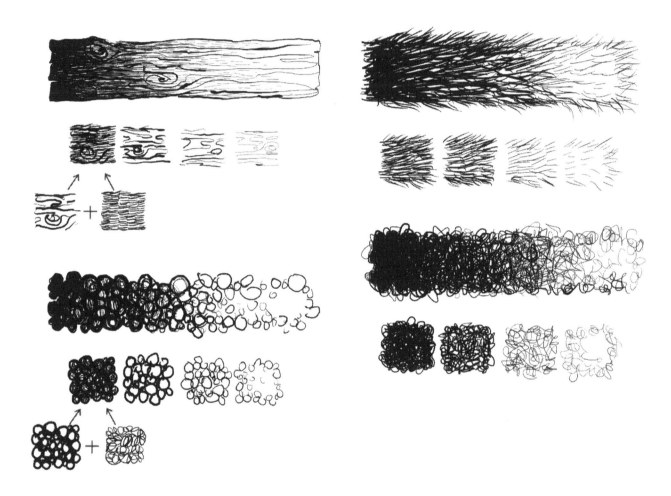

Use the variations of a stroke to convey light and shadow
Variations in spacing, weight, layers, and size are all used in these examples to represent the gradual shift from shadow to light. In the two examples on the left, a layer of a different type of stroke is added to deepen the value of the texture in shadow.

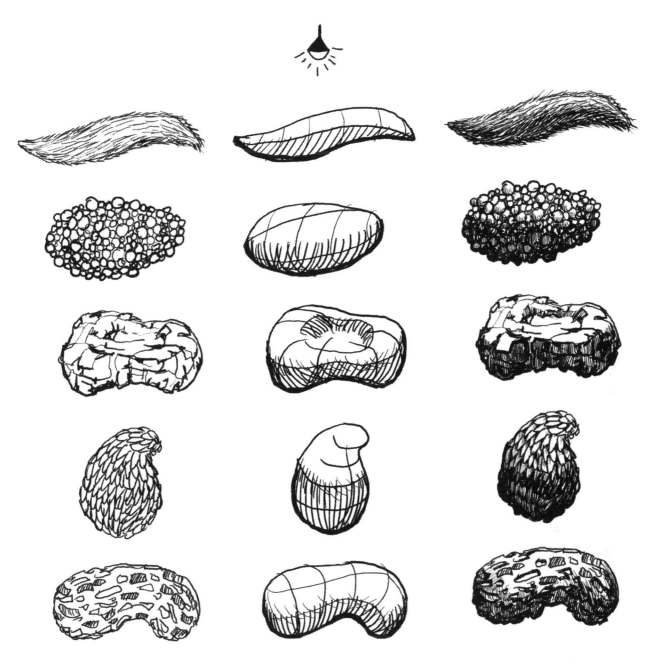

Here, the drawings remain outlines. There is no indication of a value pattern and little suggestion of light and shadow.

The focus in these drawings is on the general separation of areas in light from those in shadow. The texture is ignored to provide more clarity.

The texture of each form not only follows its cross-contour, but also conveys the value pattern as well.

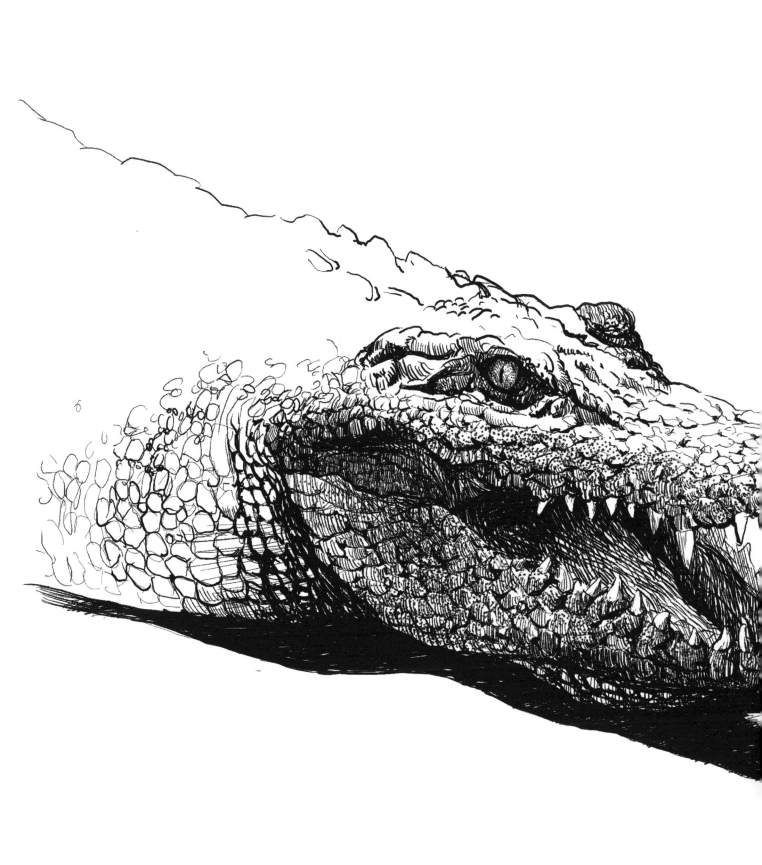

The rendering of the scales of this crocodile follows its cross-contour and value pattern. The strong light from above causes the texture on top of its snout to appear bleached, showing little details. To convey this, the strokes are made light and sparse, and with only one layer. On the shadowed side, the strokes are densely layered and much bolder.

START WITH TEXTURE ON SIMPLE FORMS

Practicing to rendering of texture on simple forms prepares you for handling subjects with complex shapes and structures. Doing this also enables you to develop your confidence and skills before taking on bigger challenges. As you render the textures of these simple forms, start thinking of the many subjects you could apply them to.

TEXTURE ON BLOCK FORMS

Creating textures for block forms presents less of a challenge than for round forms because you don't have to be concerned with curving surfaces and subtle value gradations. Block forms have flat sides, straight edges, and a simple value pattern. Use lightweight strokes in the areas of light and add additional layers over areas in shadow to deepen their value. The strokes you use for deepening the value should complement the texture's pattern.

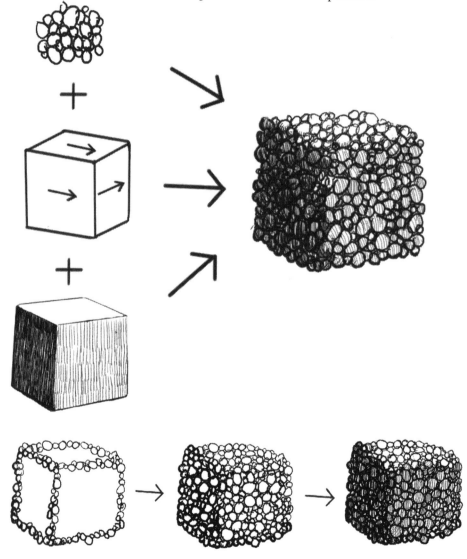

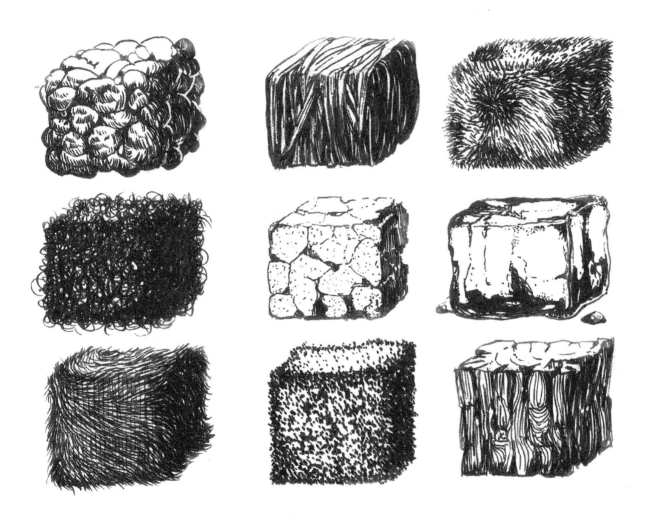

All the textures above follow the form of the block and conform to its light and shadow pattern. On the top facing plane where the value is lightest some details are left out. In contrast, details are blurred in the areas of shadow by adding additional layers of texture.

TEXTURE ON SPHERICAL FORMS

The curvature of round forms makes it challenging for many students to render their textures. As with shading, the textures of round forms should follow their cross-contour and accentuate their volume. Lightly sketching in guidelines for your strokes is an effective way to remind yourself of the path they should follow. It is also important to be aware of where the light and shadow areas meet. This marks where the transition takes place and requires that you adjust your strokes to create a gradual change in value.

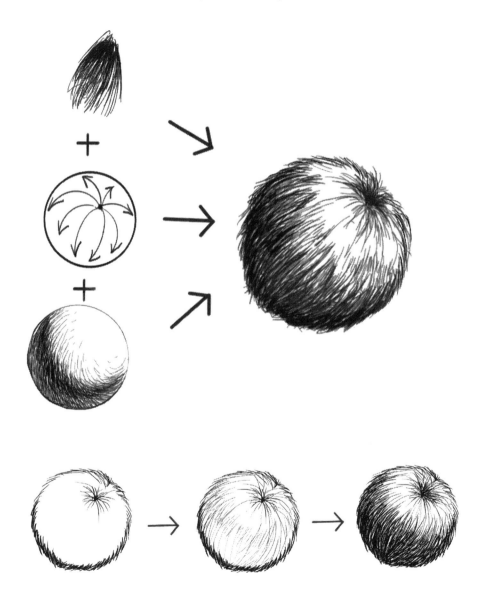

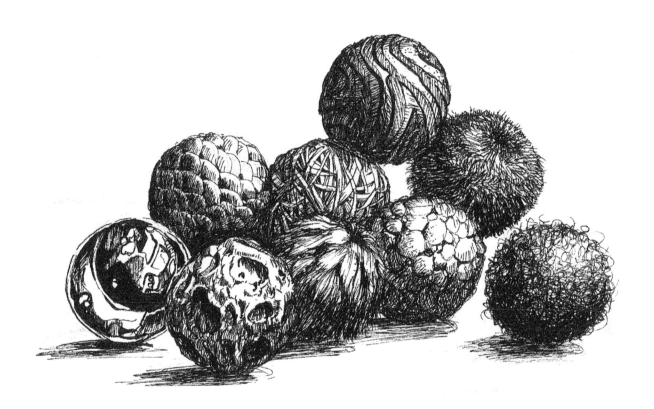

Use exercises like this as practice to prepare you for rendering complex round forms. These may just be simple spheres but they go a long way in helping you develop the skills you need. Subjects you'll encounter may not be as simple in shape or lit from the same direction but the same principles of rendering will apply.

TEXTURE ON CYLINDRICAL FORMS

Texture on a cylindrical form is gradated like on a sphere. However, the gradation does not converge to a single point; instead it wraps around the length of the form. The cylinder is one of the most useful of all the simple forms. It can be used to reduce the structure of many complex forms.

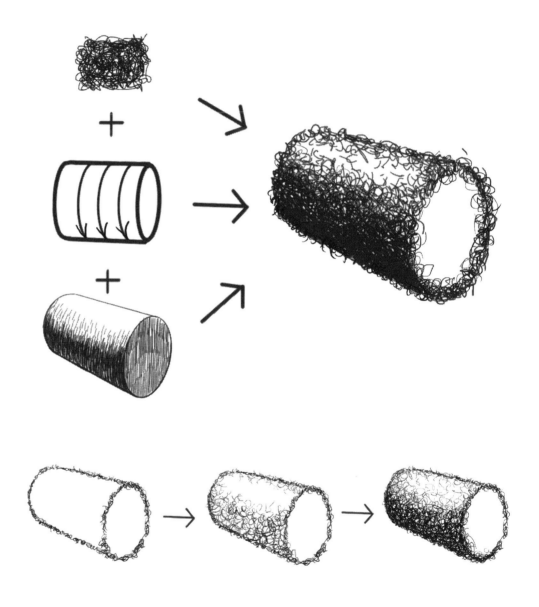

With these patterned animal fur textures the same principle applies. Each follows the cylindrical form and conveys the gradual change in value as it turns away from light to shadow.

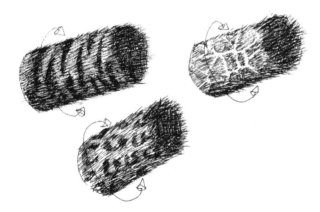

In this texture totem pole the texture gradates in value from right to left and curves around the cylindrical mass. Challenge yourself to do this exercise with at least nine different textures.

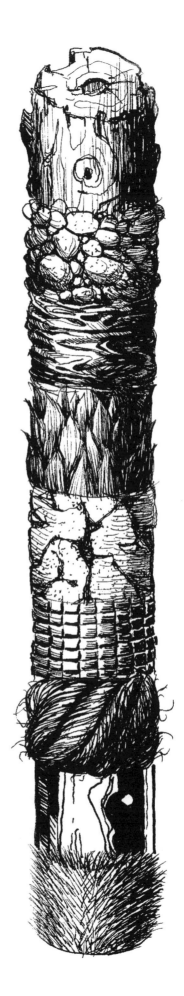

BRINGING THEM ALL TOGETHER

The stunning textures of animals provide an excellent source of practice. You can find a plethora of textures including endless types of scales, feathers, furs, and more. Study the works of artists to learn different techniques and styles of approach.

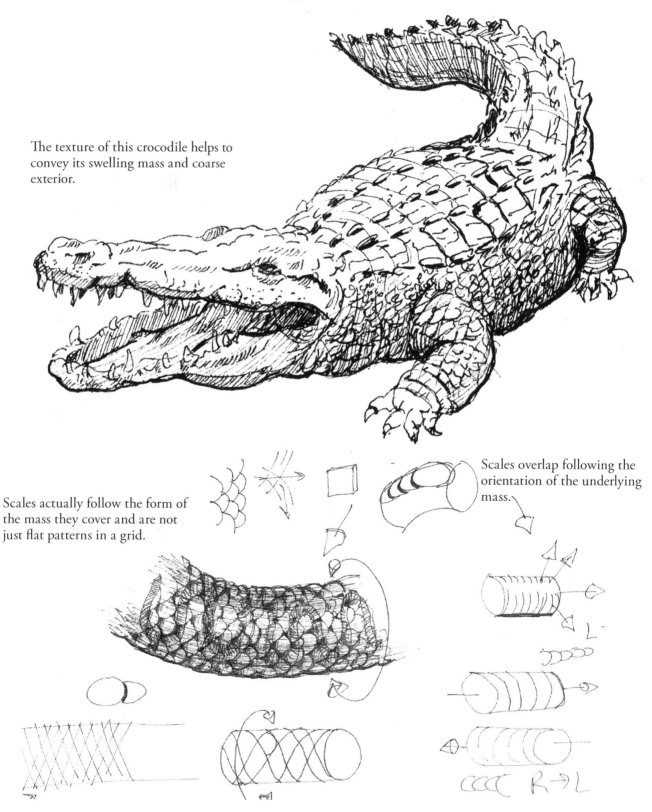

The texture of this crocodile helps to convey its swelling mass and coarse exterior.

Scales actually follow the form of the mass they cover and are not just flat patterns in a grid.

Scales overlap following the orientation of the underlying mass.

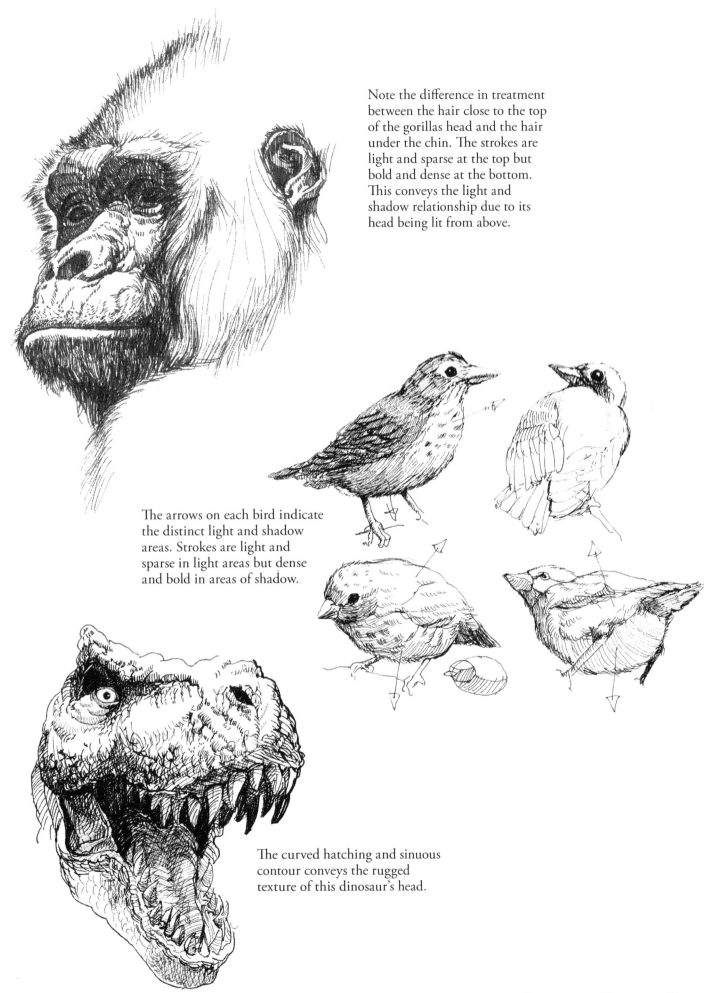

Note the difference in treatment between the hair close to the top of the gorillas head and the hair under the chin. The strokes are light and sparse at the top but bold and dense at the bottom. This conveys the light and shadow relationship due to its head being lit from above.

The arrows on each bird indicate the distinct light and shadow areas. Strokes are light and sparse in light areas but dense and bold in areas of shadow.

The curved hatching and sinuous contour conveys the rugged texture of this dinosaur's head.

You can distinguish the different textural qualities of the wood, rope, and metal parts of this pail. The local value of the metal base is created by using dense hatch marks to distinguish it from the areas next to it.

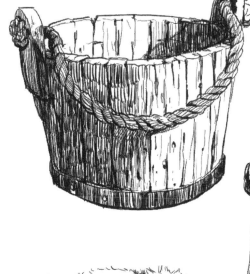

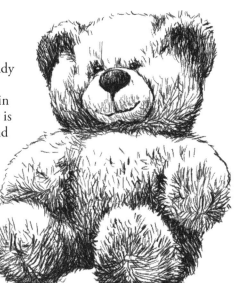

The basic structure of this teddy bear allows you to see what simple forms were visualized in its rendering. The entire body is constructed from spherical and cylindrical forms.

Note the sparse use of strokes used to depict the shade of this old lantern. The metal frame is treated with dense marks to distinguish its local value and metallic surface.

The texture of this strawberry is captured by the short hatch marks and the rendering of the achenes across its surface. Their positions are laid out around the contour of the fruit, accentuating its volume.

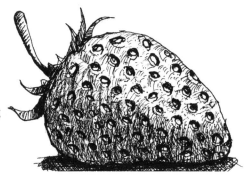

Chrome and similar surfaces require close observation of their value shapes in order to capture their textures. These types of textures are made up of abstract shapes with strong contrast and sharp edges. Strokes must be kept tight and uniform so the shapes are clearly distinguished.

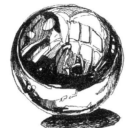

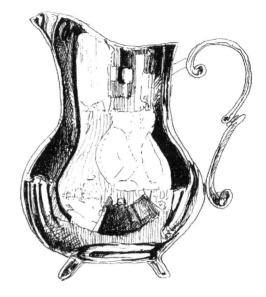

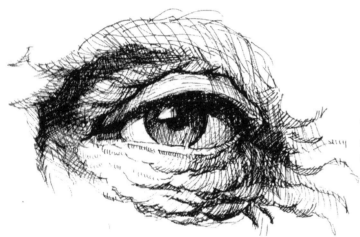

The broken forms around this eye create the texture of a face that is old and worn.

The ragged texture of this house is created by the broken and uneven contours used throughout its rendering. You cannot find a perfectly straight line or symmetrical shape; instead a sense of unevenness and sketchiness dominates all the forms and details.

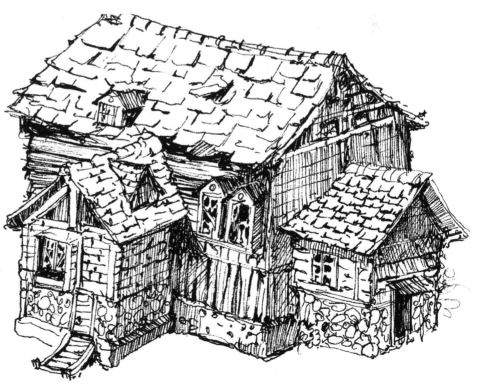

Sketchbooking

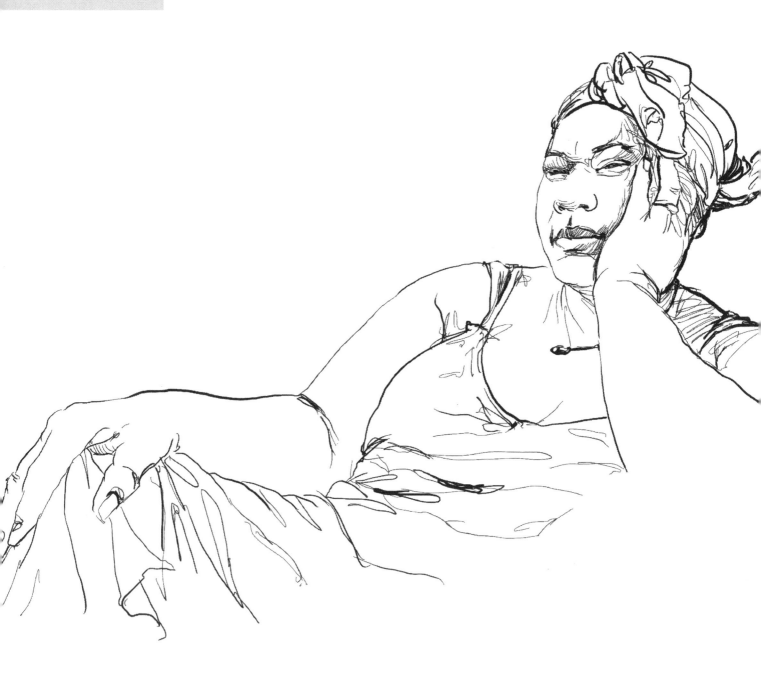

5

Every student should own at least one sketchbook. It should be like a personal diary, a place where you can let your guard down and draw without feeling you'll be judged on how good or bad it looks.

There should be no burden to get things right, no one but yourself to impress, and no limits on mistakes you can make. You are allowed to draw one thing a thousand times if you need to. It isn't just for making pretty pictures to share with the world, but where you face your fears, and work on the things you find most challenging.

Your sketchbook should be a visualization of your thought process, a record of your progress, and a platform for exploring your ideas. Don't limit your sketchbook to drawing only; jot down your thoughts, ideas, questions, comments, and even inspiring quotes. Once you learn to see it in this way, it will rarely leave your side.

Things to do in your sketchbook:
- Doodle.
- Plan and explore ideas.
- Draw silly things without feeling bad about it.
- Draw something a thousand times, if you need to.
- Create sketches for finished pieces.
- Write notes.
- Practice the basic elements and principles of drawing.
- Practice basic skills and techniques.
- Try out different instruments and media.
- Draw things you find challenging or don't like to draw.
- Draw things that interest you and those that don't.
- Draw things you would never show anyone.
- Draw things in different styles.
- Draw a wide range of subjects.
- Draw familiar things in unfamiliar ways.
- Draw lots of thumbnail sketches.
- Fasten inspiring images inside like a scrapbook.
- Do long studies and quick sketches.
- Copy drawings of other artists.
- Create abstract drawings.
- Draw from memory.
- Draw from life.

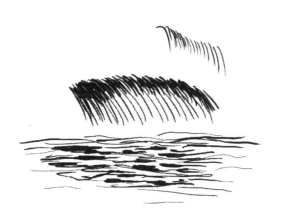

THE SKETCHBOOK IS YOUR BATTLEFIELD

To make significant progress in drawing, it is important to be aware of your strengths and challenges. Don't just say, "I'm not good at drawing faces." Try to learn specifically why you find it challenging to draw faces? Is it getting the proportions right? Shading? Anatomy? Break down challenges into small steps and tackle them one at a time. The clearer you are, the better prepared you will be for devising a solution.

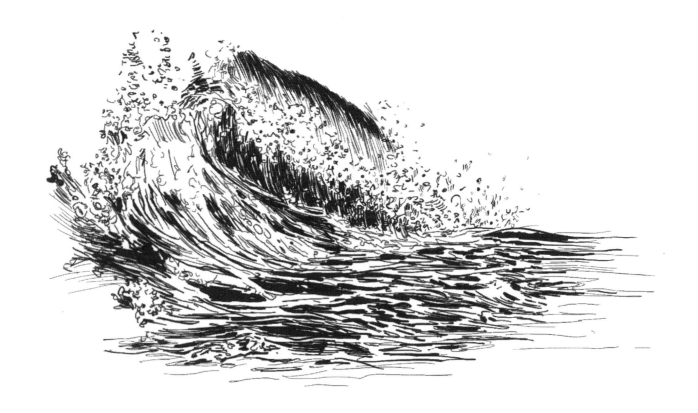

ALWAYS GO BACK TO THE BASICS

Most problems in drawing revolve around fundamental issues.
You can never have enough practice of the essential elements
and principles of drawing. Fill pages with basic exercises in
shading, textures, rendering simple forms, and so on.

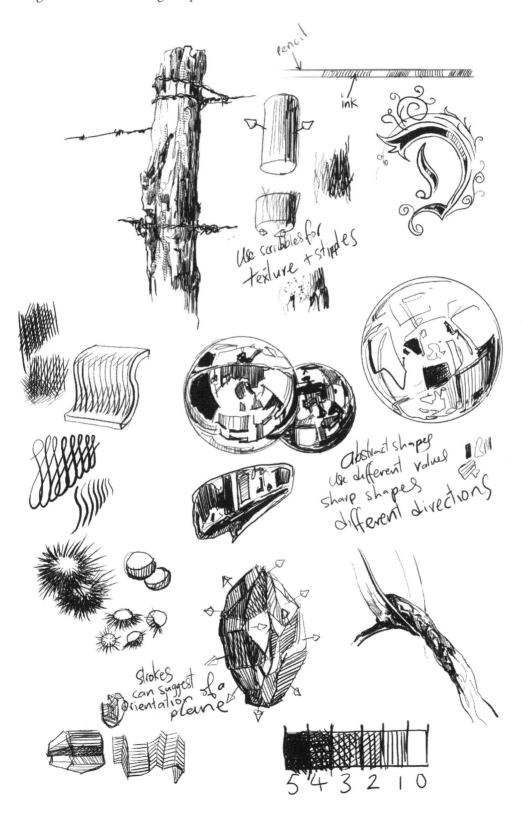

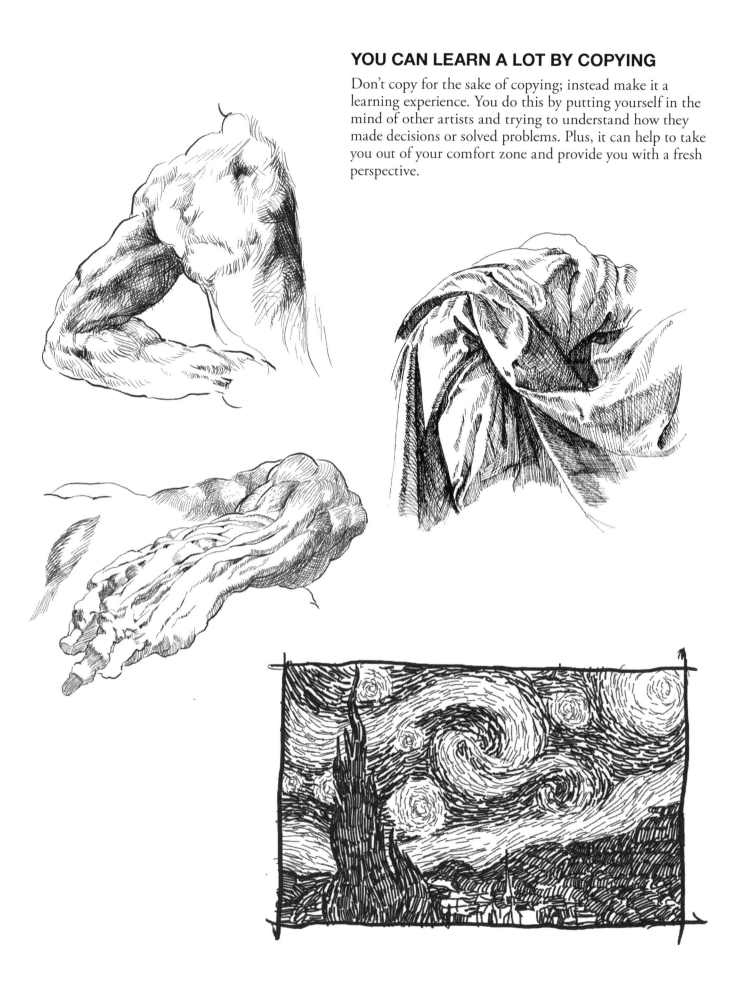

YOU CAN LEARN A LOT BY COPYING

Don't copy for the sake of copying; instead make it a learning experience. You do this by putting yourself in the mind of other artists and trying to understand how they made decisions or solved problems. Plus, it can help to take you out of your comfort zone and provide you with a fresh perspective.

REPETITION IS THE MOTHER OF LEARNING

Never be afraid to draw the same thing a thousand times if you
need to. Try not to be impatient or force progress. Remember,
everyone doesn't learn in the same way or at the same pace.
Test your comfort and confidence level by drawing a subject in
multiple positions and attempting to maintain consistent results.

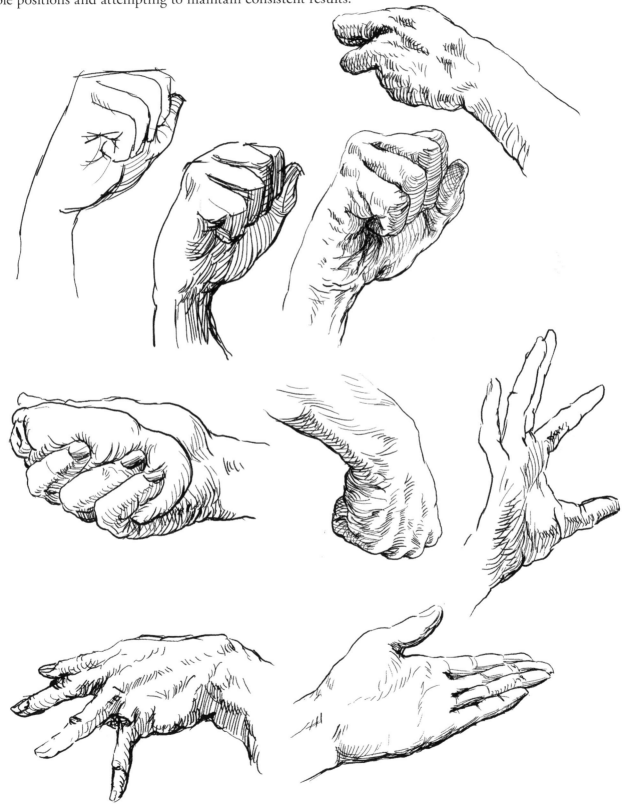

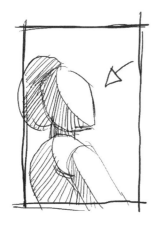

THUMBNAILS ARE INVALUABLE

Making thumbnail sketches should be an integral part of your creative process. They are small, loose, and take very little time to do. You can use them to plan and explore composition ideas, value relationships, subject proportions, and more. But they are particularly useful whenever you're weighing decisions about design and composition choices. Here, they provide quick snapshots of a few design alternatives that were considered for a portrait.

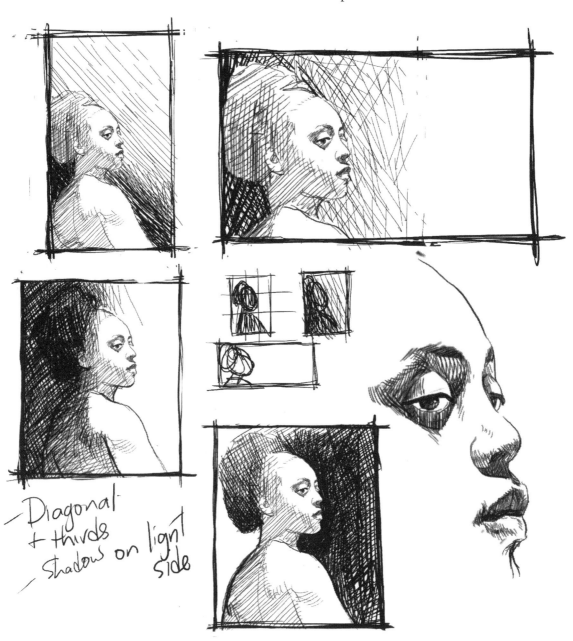

— Diagonal
+ thirds
— Shadow on light side

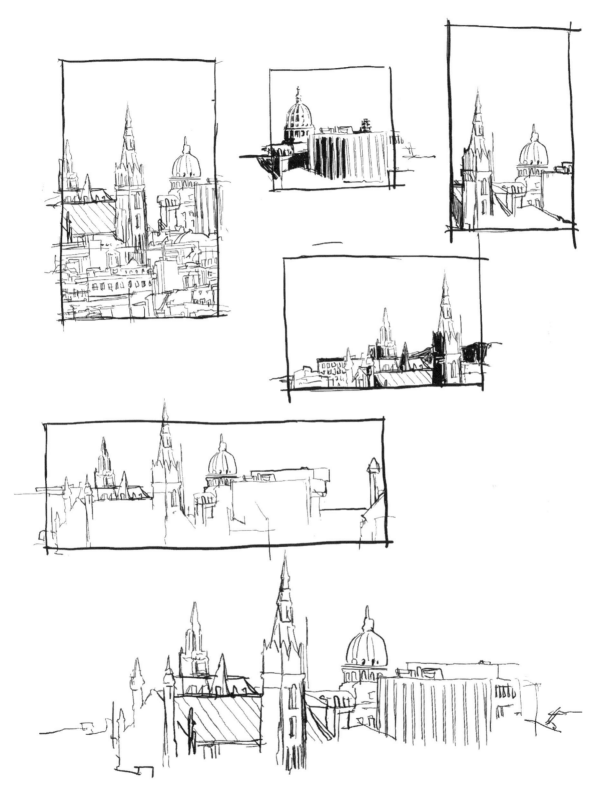

Here, thumbnail sketches are used to explore the visual impact each frame will have on the subject.

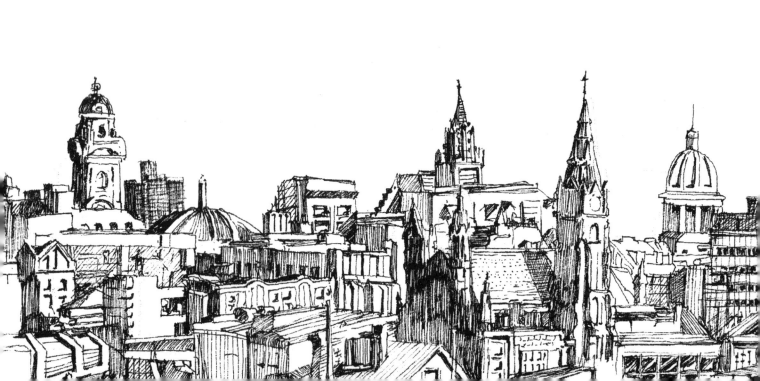

Take this as a lesson in the ways to think about designing and framing your drawings. In this example, the open space of the page is being used to frame and complement the drawing's composition. The drawing is placed at the bottom of the page allowing all the space above to allude to the open sky and create an aesthetically pleasing asymmetric balance.

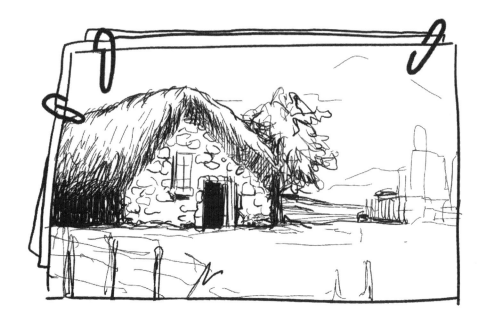

USE YOUR SKETCHBOOK AS A SCRAPBOOK

Inspiration can come at any given moment. It may be from an advertisement in the newspaper, a photograph from a magazine, a quote you overheard, or a even scene from a movie. If it's something that can be clipped, glued, taped, or otherwise fastened in your sketchbook, do it!

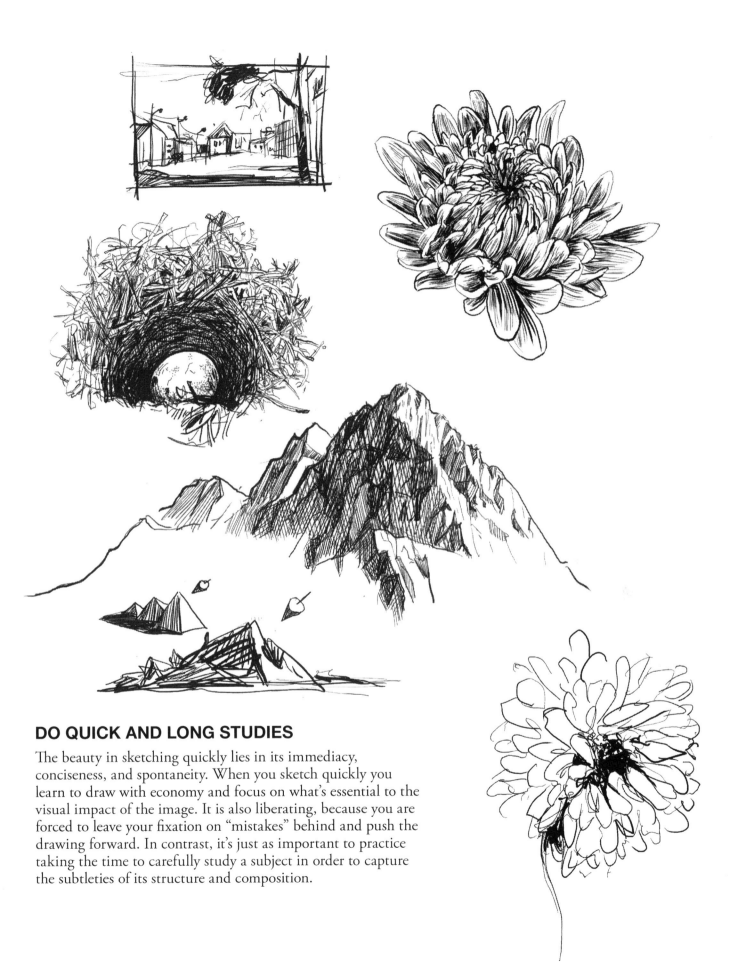

DO QUICK AND LONG STUDIES

The beauty in sketching quickly lies in its immediacy, conciseness, and spontaneity. When you sketch quickly you learn to draw with economy and focus on what's essential to the visual impact of the image. It is also liberating, because you are forced to leave your fixation on "mistakes" behind and push the drawing forward. In contrast, it's just as important to practice taking the time to carefully study a subject in order to capture the subtleties of its structure and composition.

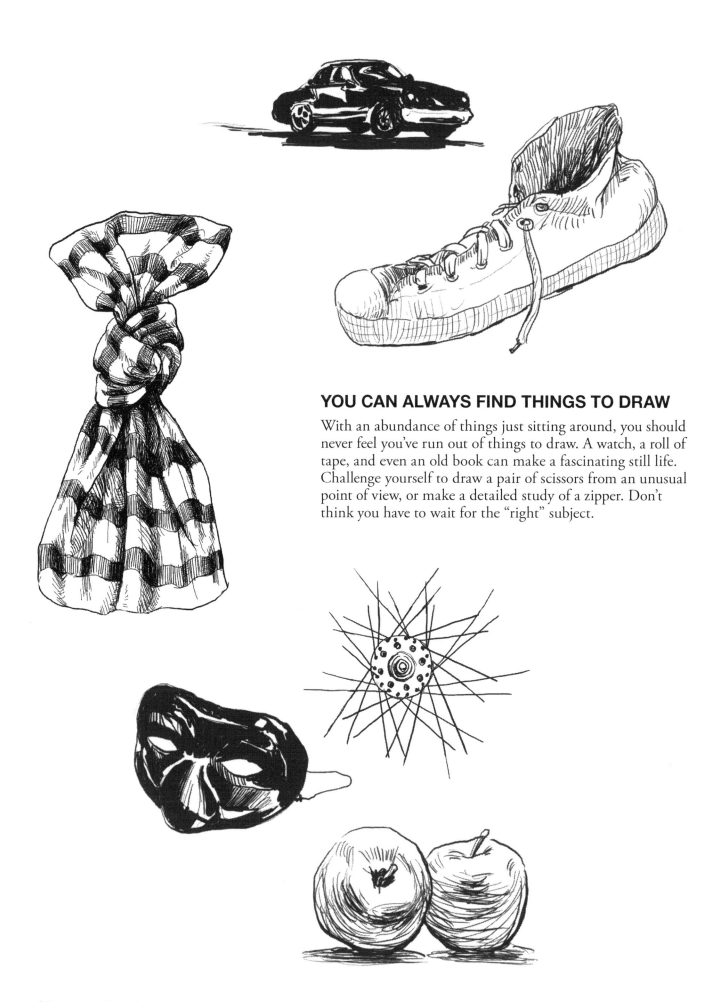

YOU CAN ALWAYS FIND THINGS TO DRAW

With an abundance of things just sitting around, you should never feel you've run out of things to draw. A watch, a roll of tape, and even an old book can make a fascinating still life. Challenge yourself to draw a pair of scissors from an unusual point of view, or make a detailed study of a zipper. Don't think you have to wait for the "right" subject.

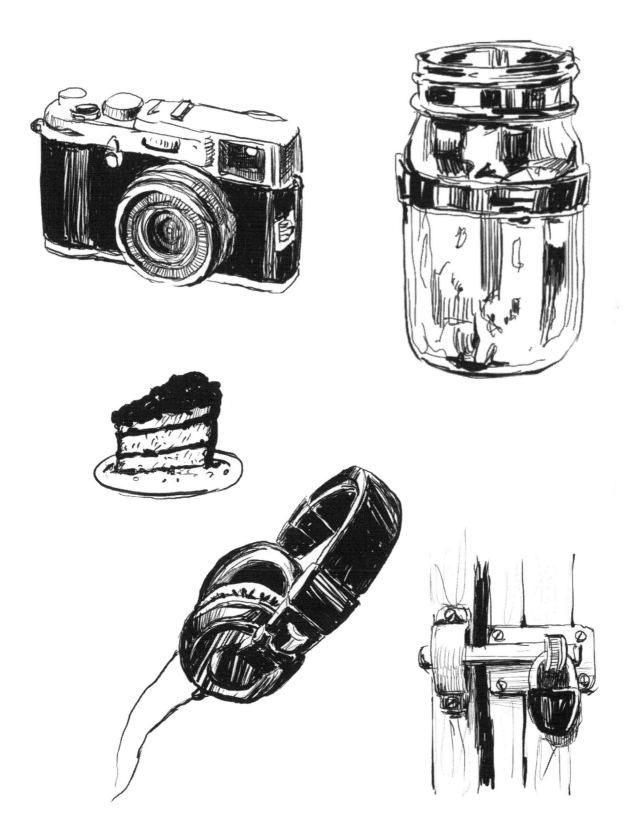

PLAY IS ESSENTIAL FOR CREATIVITY

Your sketchbook shouldn't always be a place for just serious work or practice. Sometimes you should draw simply for the fun of it, with no plan or direction, just going wherever impulses take you. This is a healthy practice because you learn not to take yourself too seriously or weigh yourself down with high expectations. Just have fun!

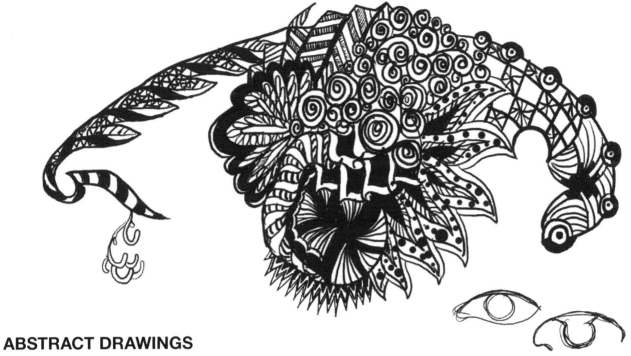

ABSTRACT DRAWINGS

Creating abstract drawings can be therapeutic and deeply satisfying. You can incorporate representational elements, use specific patterns, or just let the design evolve as they come to your mind. They require very little skill to get started and can lead to beautifully intricate and entrancing pieces.

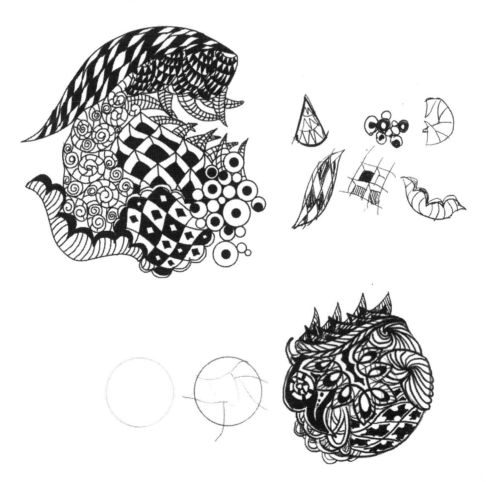

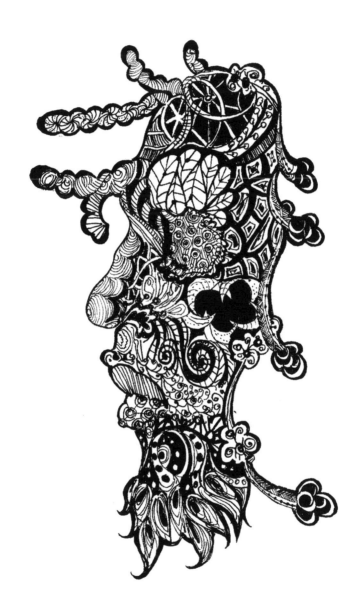

You can have lots of fun with these types of abstract drawings. In this portrait, the patterns not only fill the the design of the profile, but also allude to the structure of the features they describe.

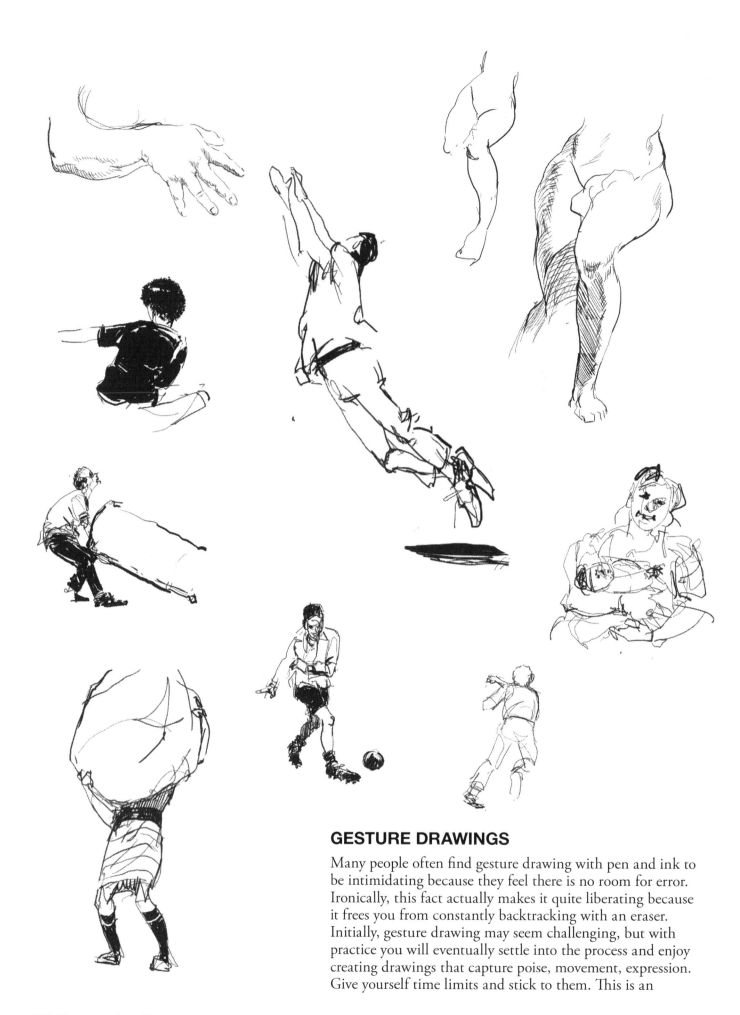

GESTURE DRAWINGS

Many people often find gesture drawing with pen and ink to be intimidating because they feel there is no room for error. Ironically, this fact actually makes it quite liberating because it frees you from constantly backtracking with an eraser. Initially, gesture drawing may seem challenging, but with practice you will eventually settle into the process and enjoy creating drawings that capture poise, movement, expression. Give yourself time limits and stick to them. This is an

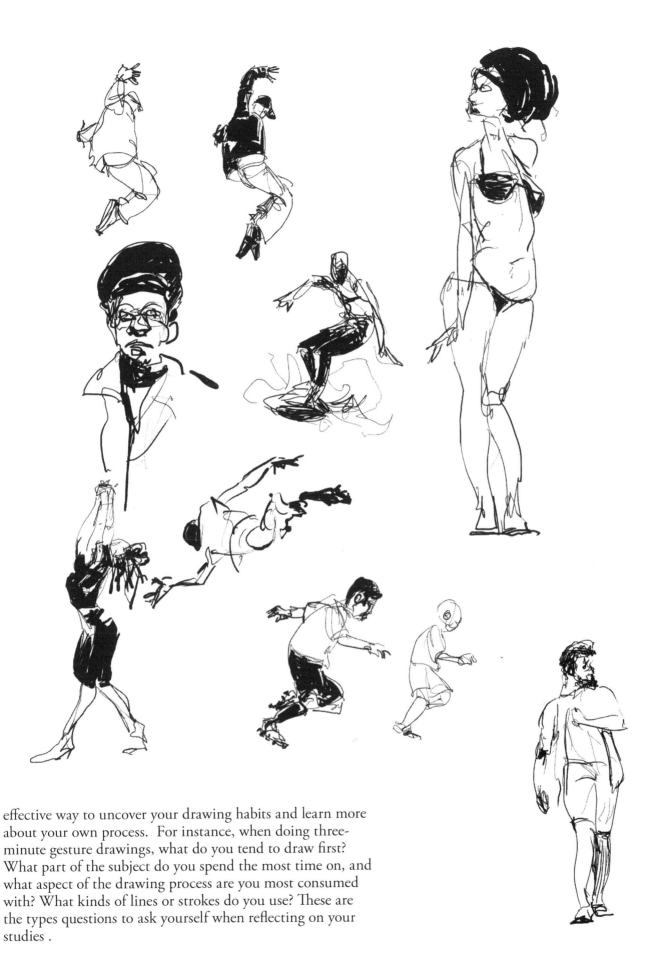

effective way to uncover your drawing habits and learn more about your own process. For instance, when doing three-minute gesture drawings, what do you tend to draw first? What part of the subject do you spend the most time on, and what aspect of the drawing process are you most consumed with? What kinds of lines or strokes do you use? These are the types questions to ask yourself when reflecting on your studies .

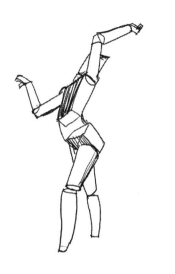

THE HUMAN FIGURE

For many students the human figure remains one of the most challenging subjects to draw and sketch. However, like with any other subject, you develop mastery by breaking it down into simple components and studying each individually. First, memorize the general proportions of the human body; then practice laying them out from memory. This establishes a visual reference in your mind that you can use either to construct the figure from imagination or apply to a figure

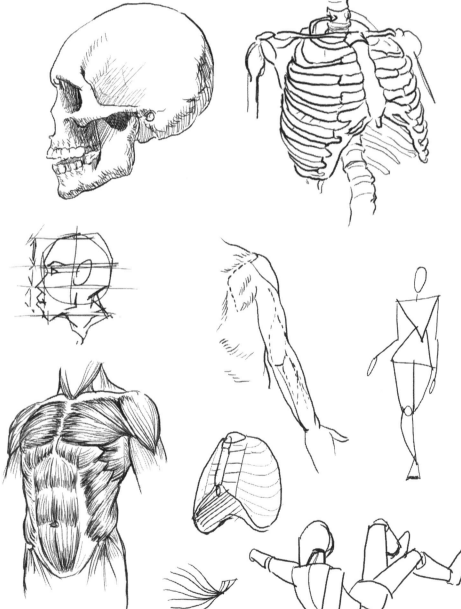

you draw from observation. Some anatomy is useful to know, especially of the major bones and muscle groups that create the features we see on the surface. And rendering the figure is not much different from rendering simple forms like, eggs, spheres, blocks, and cylinders. It will take some practice to learn to visualize it in this way, but eventually, rendering the figure will become much easier.

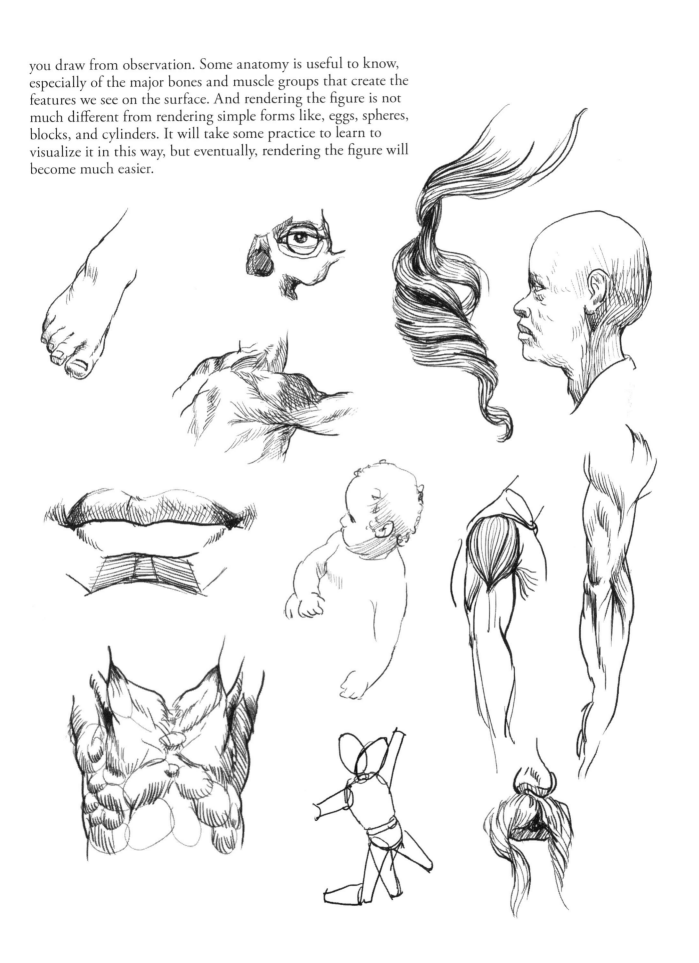

FACES AND PORTRAITS

The face is one of the most popular subjects in art. And if you wish to get better at drawing them, the place to do it is in your sketchbook. Start by breaking apart the different aspects of a portrait and work on each one individually. Dedicate pages to each if you need to. If the features are your biggest challenge, work on them one at a time. If it's shading, then study the planes of the head and draw lots of them reduced to simple block forms. And if getting the right proportions is an issue, use construction lines to map out where things are until you can get it right from memory.

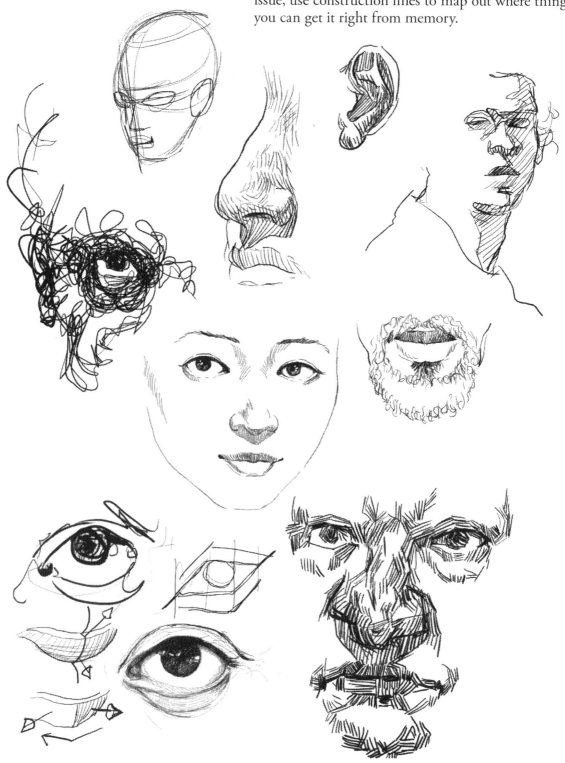

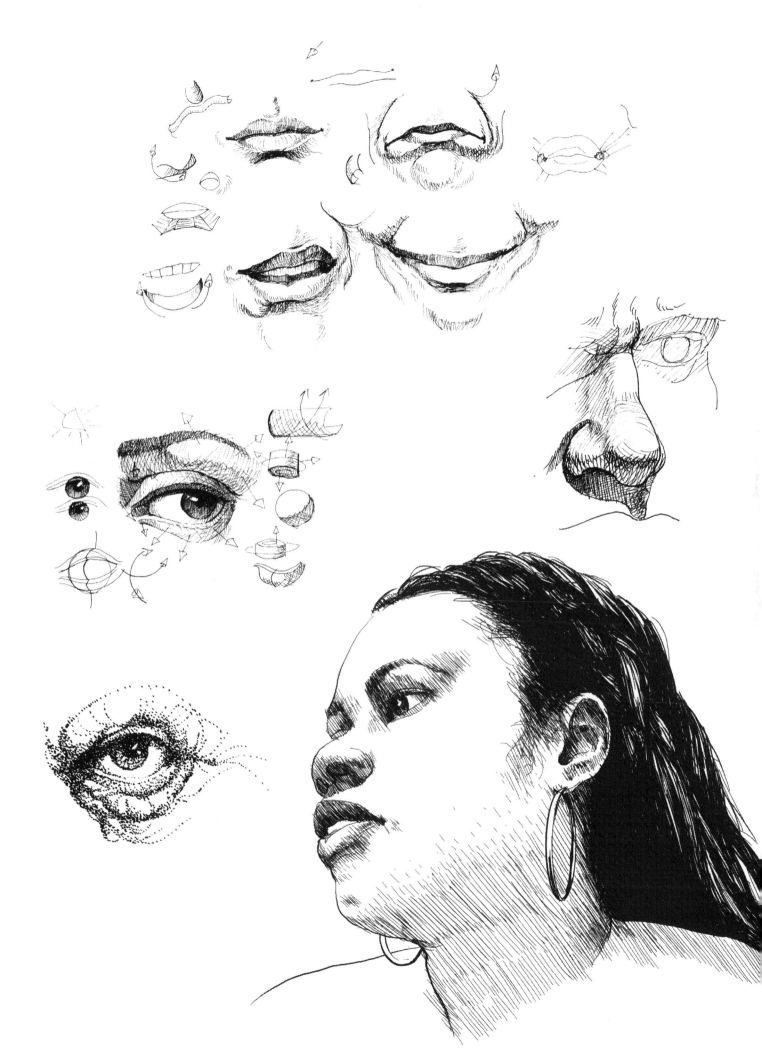

Enough emphasis cannot be placed on the importance of establishing proper proportions in drawing portraits. Not only must the features relate to each other proportionately, but the parts of each feature must also relate to each other as well.

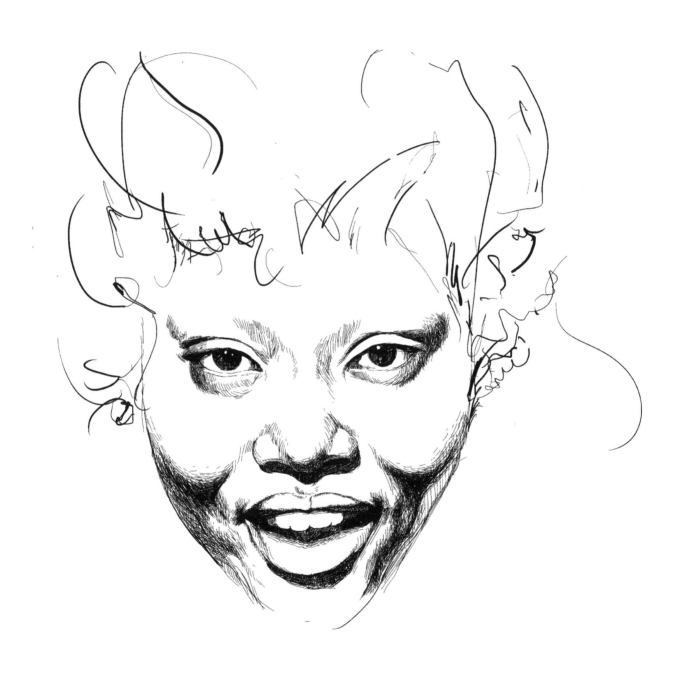

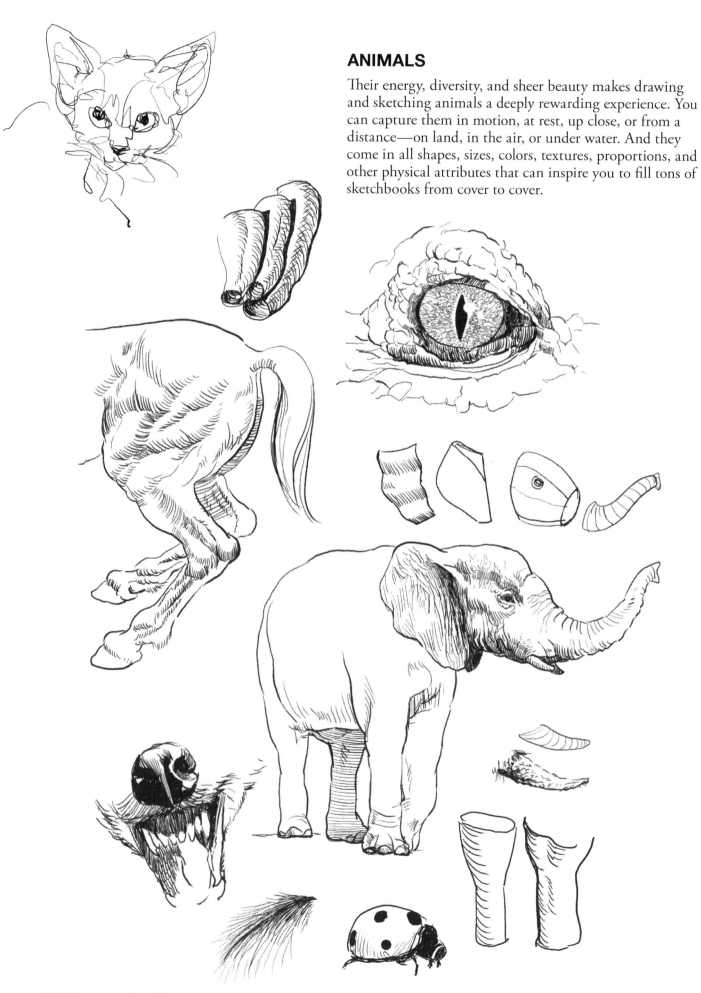

ANIMALS

Their energy, diversity, and sheer beauty makes drawing and sketching animals a deeply rewarding experience. You can capture them in motion, at rest, up close, or from a distance—on land, in the air, or under water. And they come in all shapes, sizes, colors, textures, proportions, and other physical attributes that can inspire you to fill tons of sketchbooks from cover to cover.

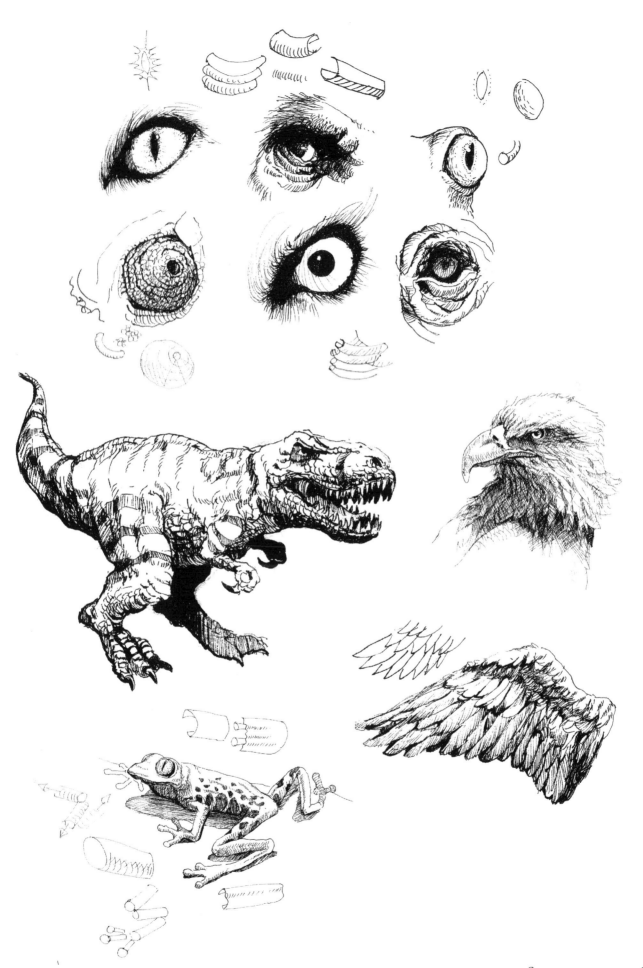

SKETCHING SCENERY

Make it a habit to take your sketchbook wherever you go. Whether you're traveling through a bustling city or a quiet suburb, you can always find something interesting that's worth recording. This doesn't have to be an entire scene, it could be a single feature like a tree, or branch, or even a rock. It is important is that you think of drawing as a way of exploring and connecting with the world around you, so each time you sketch you're presented with an opportunity to learn something new.

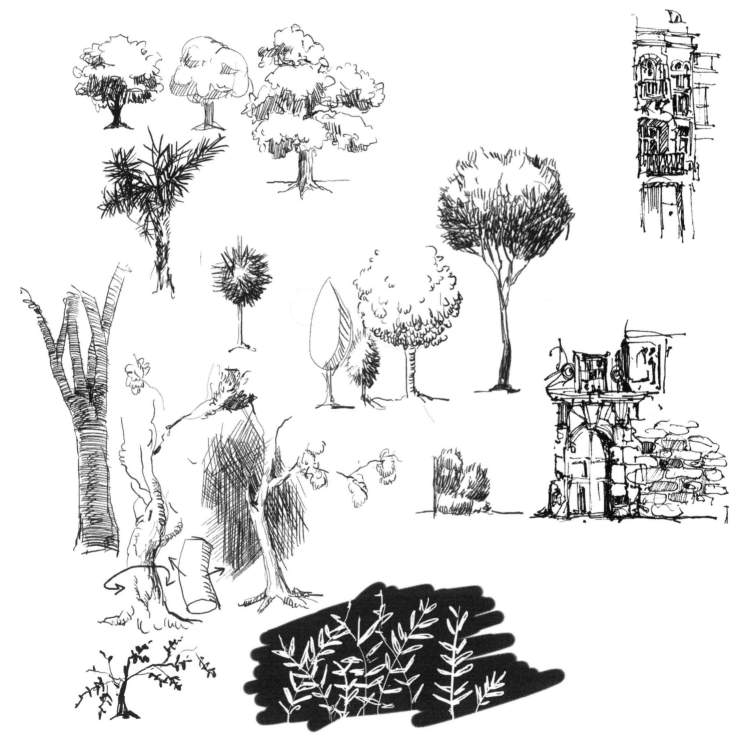

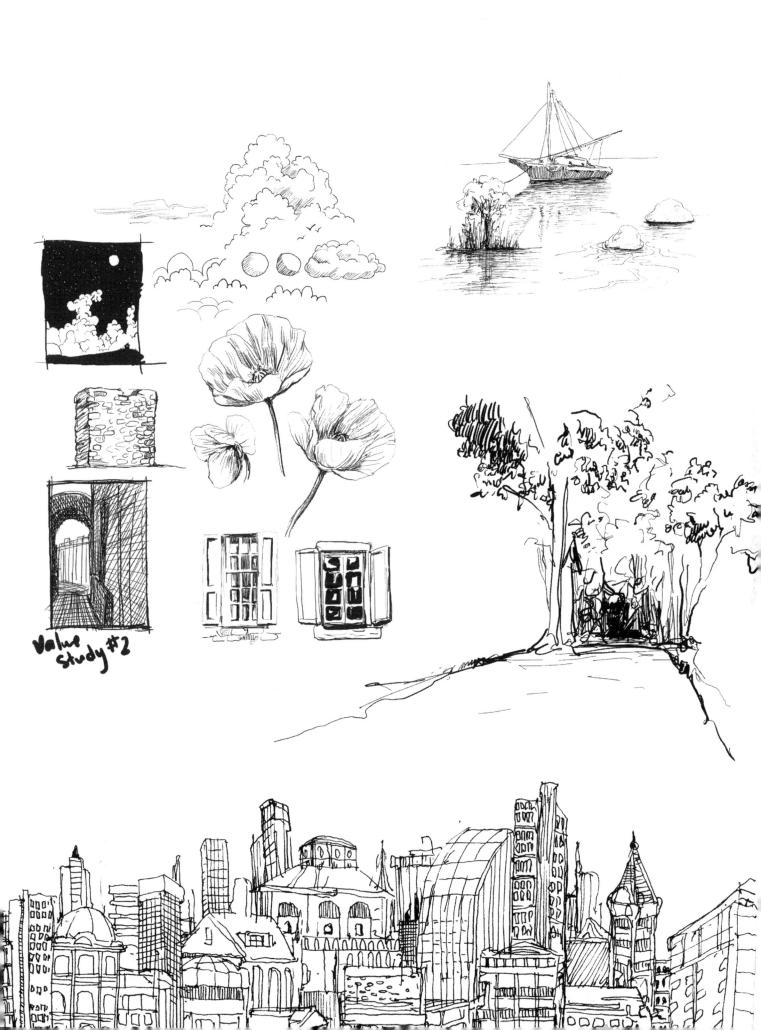

Value
Study #2

Flowers are perfect for practicing pen control and subtlety in rendering. As fragile and graceful are the soft petals of a flower, so should your lines and handling of the pen be.

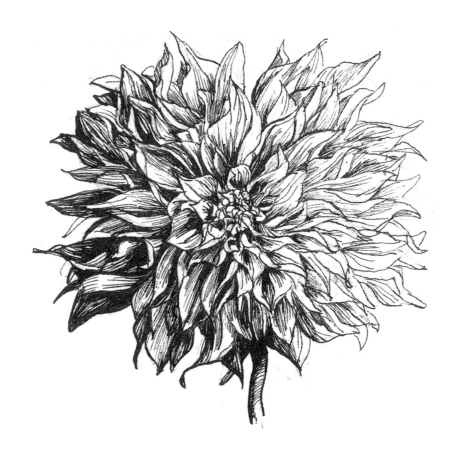

DEVELOP YOUR OWN DRAWING PROCESS

As you work on becoming better at drawing, take time to reflect on your process. This simply means you pay attention to the way you approach and work through a drawing from start to finish. Make notes or diagrams as reminders of how you solved a problem or overcame a challenge. Separate steps or stages you went through and try to understand the reasoning behind the choices you made. These reflective practices will help you to develop an understanding of your habits and tendencies and enable you to have more creative control over the outcome of your drawings.

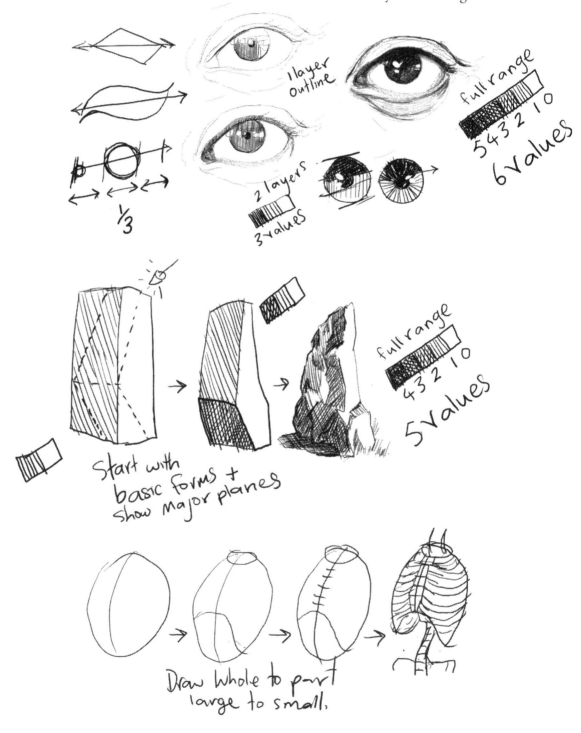

1 layer outline

full range
5 4 3 2 1 0
6 values

2 layers
3 values

Start with basic forms + show major planes

full range
4 3 2 1 0
5 values

Draw whole to part large to small.

CREATING NEW NEW IDEAS

When trying to stimulate novel ideas don't be afraid to make unconventional decisions. Try combining the features of different things that don't seem to go well together; then see what new suggestions they create. Ask "what if" questions; then draw the answers you come up with. You'll be pleasantly surprised at how fast your mind can conjure up a bounty of fresh visuals. These types of exercises help you to see familiar things from new perspectives, while maintaining a fun and playful attitude in your creative process.

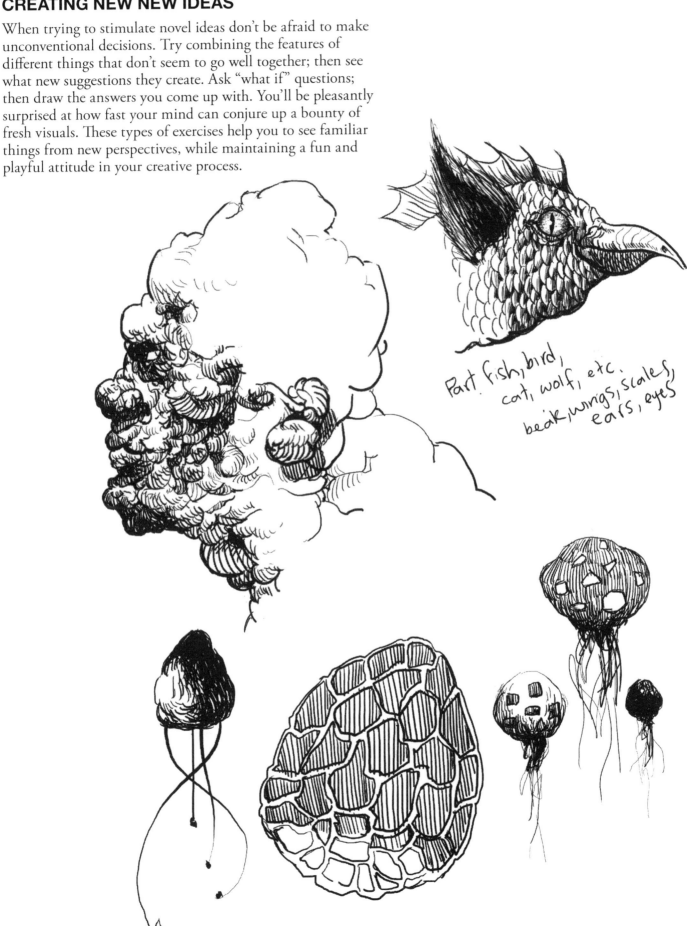

Part fish, bird, cat, wolf, etc.
beak, wings, scales, ears, eyes

Stages of a Finished Drawing

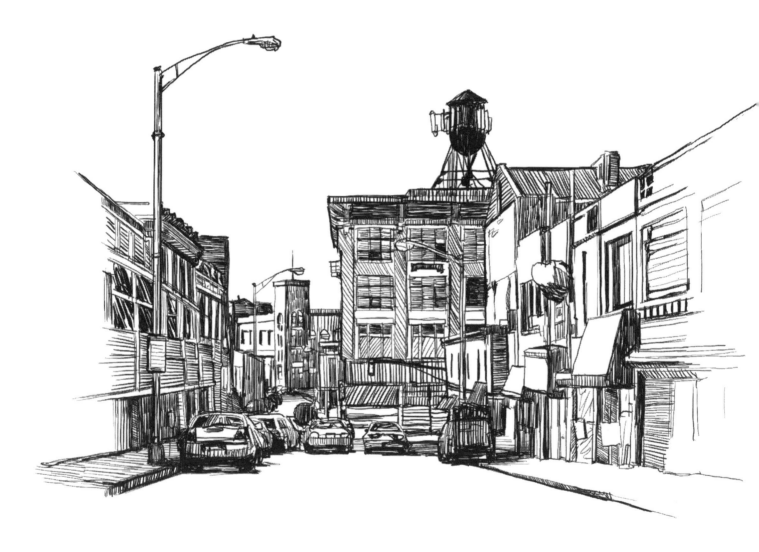

6

The most intimidating aspect of drawing with ink is not being able to erase or easily correct mistakes. This makes creating a polished pen and ink drawing a dreaded task for many. However, by taking the preliminary steps to work out composition issues and create a layout in pencil, you can relieve much of the pressure to get things right. This can do much for boosting your confidence in handling this seemingly elusive medium.

And while there are different approaches to completing a polished pen and ink drawing, it is always best to develop your drawing in stages. The three-stage model presented here provides an effective method that will enable you to be at ease and have control over the entire process and final outcome of your piece. It involves planning, sketching, pencilling, and finally, inking the drawing.

Stage 1: Composition & Design

This stage involves all the preparatory work involved in creating the final composition.

- Work out general aspects of the drawing's design.
- Research the subject and acquire reference images, if needed.
- Determine your approach to rendering the subject and identify elements that you may need to practice.

Stage 2: Pencil Underdrawing

This serves as the final roadmap for the inking to follow. It doesn't have to be a complete rendering or exact to every detail.

- Create an outline of the entire drawing.
- Layout the overall value pattern and highlight the treatment of details and other relevant areas.
- Jot notes down *on* the drawing as reminders, if necessary.

Stage 3: Inking

Although you have carefully planned your work up to this point, take your time to work steadily and not rush your inking. Applying ink is like cooking. With each ingredient added, you wait for it to take effect, then you assess the overall progress of things before moving forward.

- Build up your inking in layers.
- Work gradually from light to deep values.
- Work from general shapes and outlines to details.

Remember, you don't have to plan how you will ink every detail, you can (and should) leave some room for spontaneity and invention as you go along. This makes the process a little less predictable and still leaves the door open to new possibilities.

DEMO: NEIGHBORHOOD SCENE

This drawing will demonstrate the process of completing a fully rendered pen and ink drawing of a simple neighborhood scene. The process you learn here can essentially be applied to virtually any subject you wish to depict.

STAGE 1: COMPOSITION & DESIGN

The drawing is being done from a reference photograph. Several photos are taken of similar scenes and from different viewpoints until one with the most favorable design is chosen. Whether you draw from life or photographs, be sure to explore several alternatives before selecting your final composition.

Create your own composition
Don't think you're limited to only what's in front of you. Your final composition can very well be a composite of details from your observation, photographs, and your imagination.

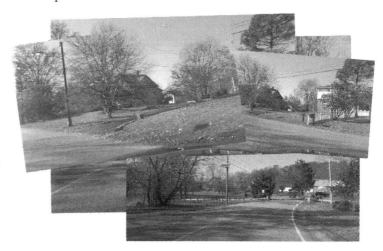

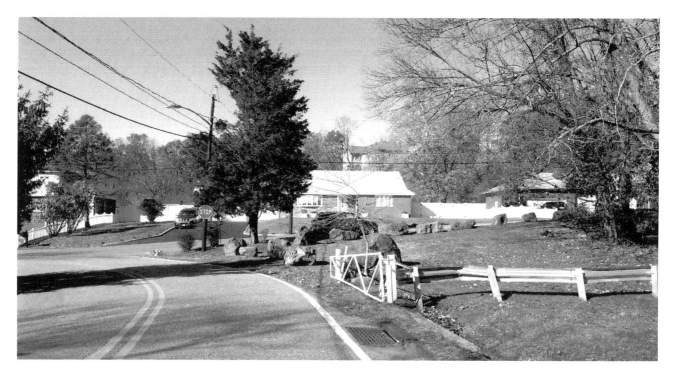

This photograph provides a composition with a variety of features, textures, values, and other interesting elements to create a dynamic drawing.

Choose a fitting frame

Carefully decide how you will frame your drawing because the frame can have a significant influence on its visual impact. Some scenes will intuitively suggest a fitting choice, while others will require some experimenting.

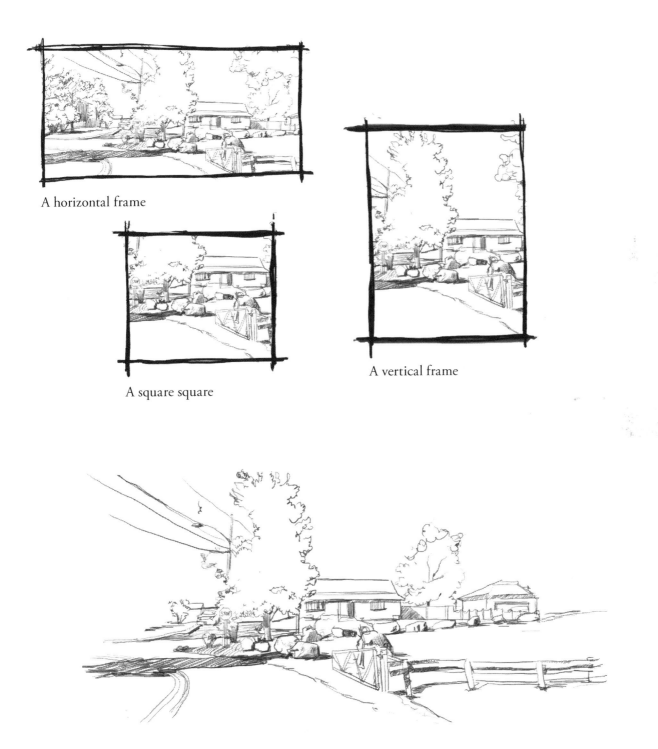

A horizontal frame

A square square

A vertical frame

Some drawings work best with no frame at all.

Simplify the scene

Reducing the scene to simple shapes makes it easier to work out various compositional elements such as balance, emphasis, proportion, and contrast.

A sketch like this comprised of only a few simple shapes provides some much needed clarity when working out composition and design issues. The same can be done for a figure, portraits, or other subject.

A sketch like this helps you to determine the most fitting lighting conditions to apply. Lighting can play an important role in conveying mood and atmosphere in your drawing.

Make thumbnail sketches and value studies

Use thumbnail sketches to work out the overall value pattern of the drawing. Address questions like, where will the area of focus be? And how will values be used in service of this? Determine the placement of your deepest and lightest values, as well as your strongest contrast.

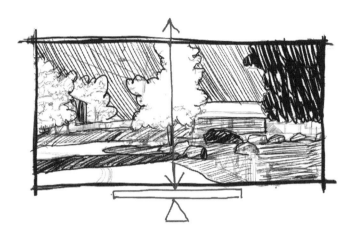

In this value study, the dark shape at the right creates an imbalance and draws too much attention away from the rest of the drawing.

The deepest value is centered in this study. This creates a focal area that almost bisects the composition. Although this goes against the general rule of thumb it still creates a pleasing design.

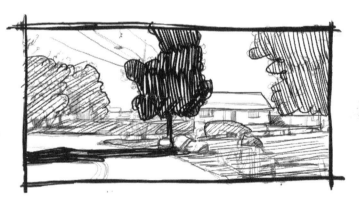

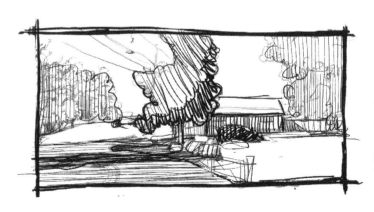

This value study lacks a strong enough contrast to establish a decisive focal area. Contrast makes a drawing more dynamic and visually engaging.

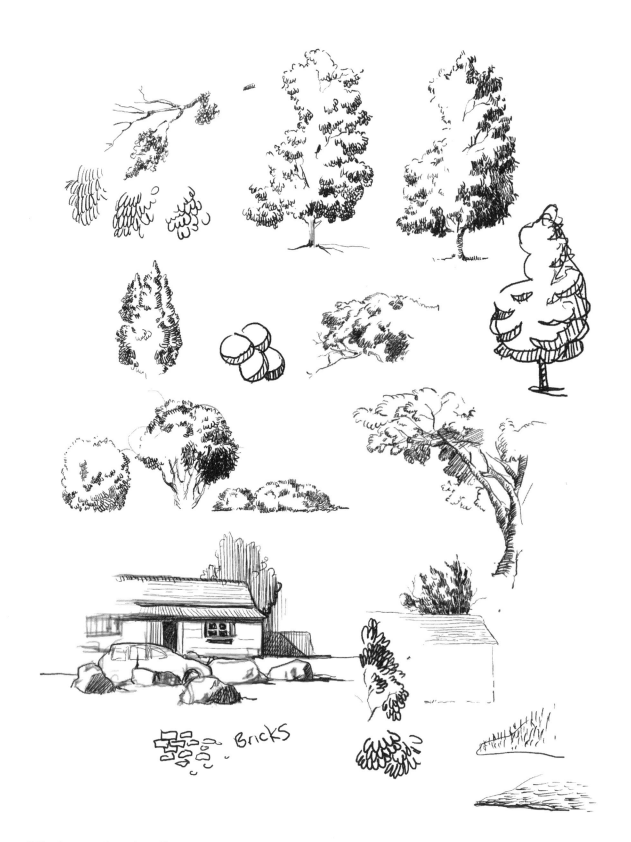

Bricks

Work out the details

Do practice exercises on areas of the subject you think you may find challenging. Experiment with different approaches and styles of rendering and get a feel for what direction your inking should take.

STAGE 2: PENCIL UNDERDRAWING

Remember, pencil is erasable, so don't limit yourself to just the underdrawing. Feel free to add notes, sketches, diagrams, or other notations on the drawing that can serve as reminders or references. Avoid using pencils with leads that are too hard or too soft. Pencils that are too hard may score the paper, and those that are too soft smudge easily and can be difficult to erase. A good choice is a regular HB graphite pencil that has medium strength and is easily erasable.

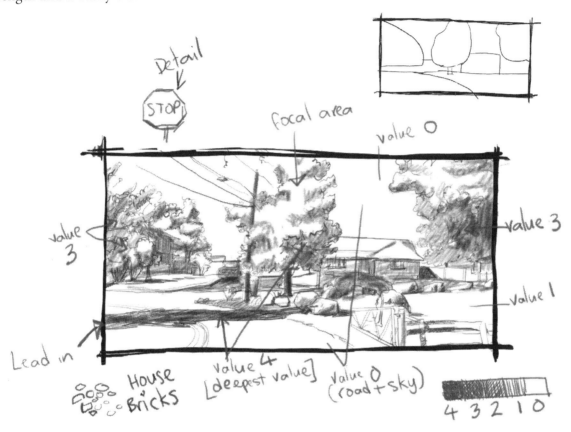

In the example above, the notations, labels, value scale, sketch, and diagram all make up the underdrawing. Take advantage of the fact that pencil is erasable, and include any extra information that will aid with your inking.

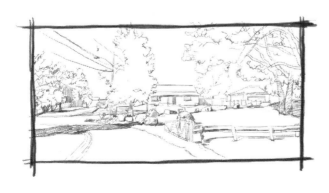

Your underdrawing can be just a simple outline drawing. This leaves room to improvise with your inking and allows you to work with a lot less clutter.

STAGE 3: INKING

Creating a finished ink drawing requires patience, a steady hand, and consistent mark-making. It is good practice to apply your inking in layers. This allows you to have snapshots of the drawing's overall progress and makes it easier for you to maintain consistency throughout. Be careful not to rush your shading or over-model areas ahead of others.

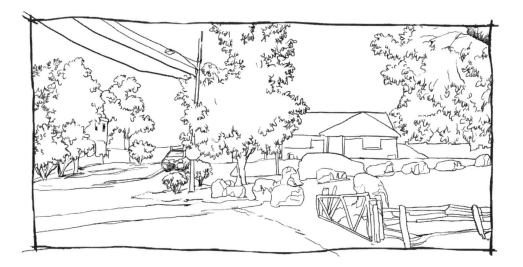

First Layer: First, establish an outline before you start any shading. Use thin lines for areas in light, and bold lines for areas in shadow. This helps to set the tone for the shading to follow.

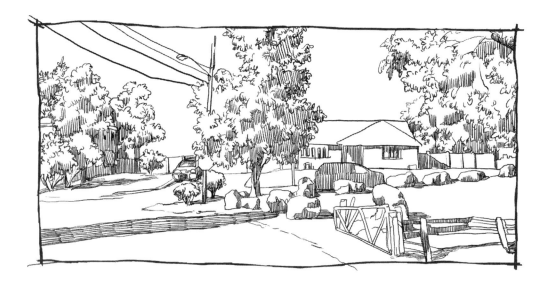

Second Layer: This first layer of shading serves as a broad separation of the light and shadow areas. The strokes should be consistent and light to create a harmonious undertone that will hold the drawing together.

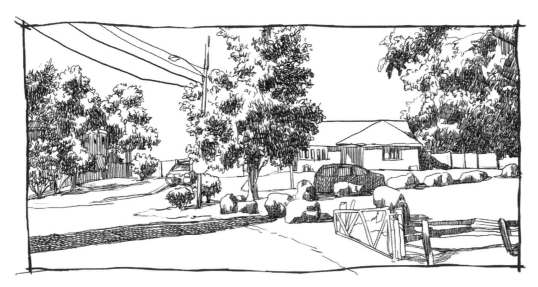

Third Layer: Deepen and expand the drawing's value range by beginning to model the gradations between light and shadow areas. The forms will start to take shape as subtle plane changes are defined, and care must always be taken to maintain the drawings overall value pattern. Here, we can see more definition in the trees, rocks and houses. The shadow areas throughout the drawing are deepened in value.

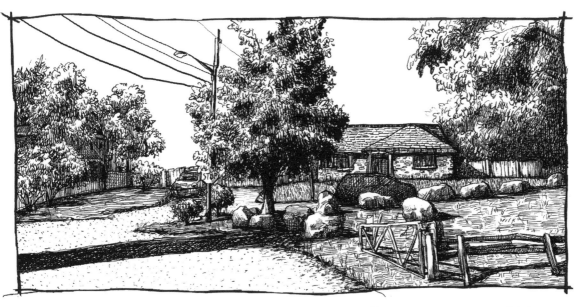

Final: As the drawing approaches completion, stop occasionally to asses its progress. Check for consistency and ensure the overall value pattern is in alignment with the design you intended. This is the time for fine-tuning and adding the finishing touches to textures, values, and small details. The textures of the road, grass, fence, roof, and bricks are clearly defined, and the leaves of the trees are fully developed.

Take your time in planning and developing the
composition of drawings you intend to fully render.
Practicing your handling of details in advance will
enable you to focus on enjoying the process of rendering
with a sense of control and direction.

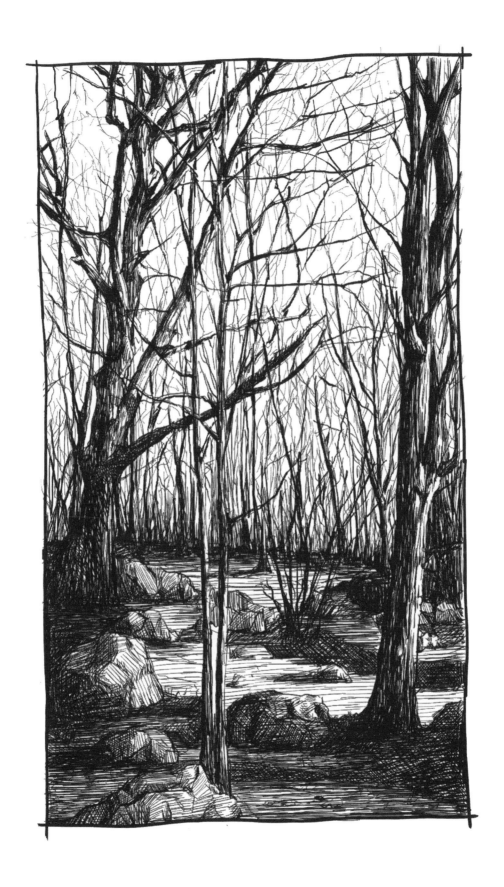

Secret Line of Balance

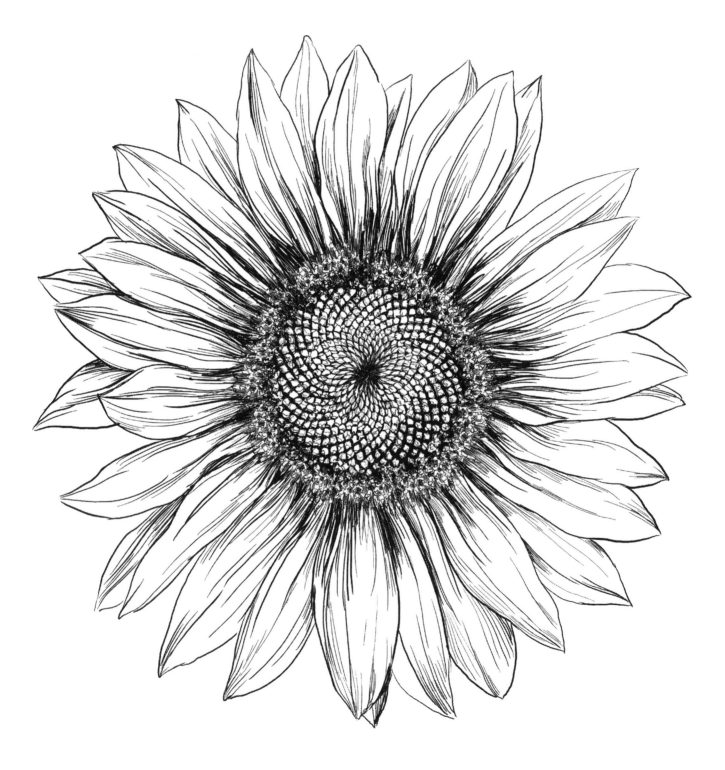

7

For thousands of years the concept of complementary opposites has been integral to man's understanding of the way nature maintains balance and stability. In essence, it asserts that elements which appear to be opposites are actually interdependent. They are more like halves of a circle working seamlessly together to form a whole. So, although they appear to be opposites, you cannot have a push without a pull, light without shadow, hot without cold, nor a positive without a negative. Ultimately, for every action there is an equal and opposite reaction.

And in a truly fascinating way, this concept is found even in the design and structure of natural forms, and is revealed through what I refer to as the Line of Balance. You may have seen it before as the shape of the sigmoid function in math, the f-hole on violins, and the curve found in the yin yang, an ancient Chinese symbol of duality. The Line of Balance is, essentially, a sinuous curve consisting of two opposing arcs, like an s-curve. However, unlike an s-curve, the arcs of the Line of Balance are not necessarily symmetrical. This allows it to appear in several variations, which may explain why it has not been so obvious to more people.

Once you become aware of this special line, you will rarely see and draw the natural forms of plants, animals, or the human figure without thinking about how it contributes to their shape, structure, and rhythm.

What can it do for you?
- It helps you to capture the essential rhythm of the structure and movement of natural forms.
- It deepens your appreciation of the surreal harmony that connects all elements of nature, both physically and conceptually.
- It provides you with a new and fascinating way to see the shape and contour of countless natural structures.
- It enables you to invigorate forms with energy and life.
- It enhances your perceptional and observational skills, given the awareness of its prevalence.

THE LINE OF BALANCE

Consider this special line a visualization of the concept of complementary opposites and balance. Conceptually, you can think of it as resulting from two opposing forces working, interdependently, as one. The two arcs both oppose and balance each other simultaneously. When one swings up, the other, counterbalances, and swings down, and vice versa.

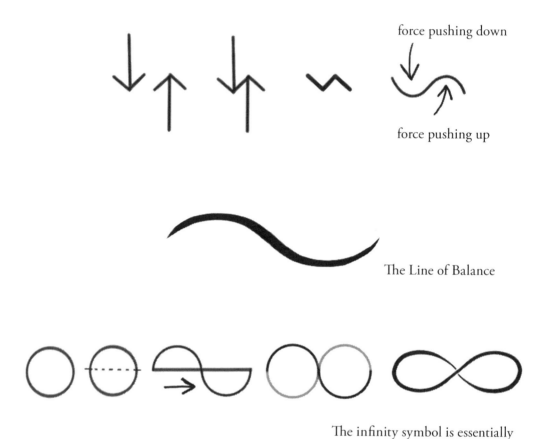

force pushing down

force pushing up

The Line of Balance

The infinity symbol is essentially two Lines of Balance combined.

Ancient symbols of balance
These are just some of the symbols of ancient civilizations that have been used to represent beliefs in the importance of balance, complementary opposites, and divine harmony.

Variations of the Line of Balance

In most cases, the Line of Balance does not appear with two symmetric arcs. Instead, it takes on a variety of forms in which the arcs differ in size and shape. Here we can see several examples of its variations.

Combinations of the Line of Balance

A wealth of forms can be achieved when you combine two or more Lines of Balance. These are just a few of the easily recognized forms created from combining two of them. Try to come up with as many combinations as possible, and think of what natural forms they evoke in your mind.

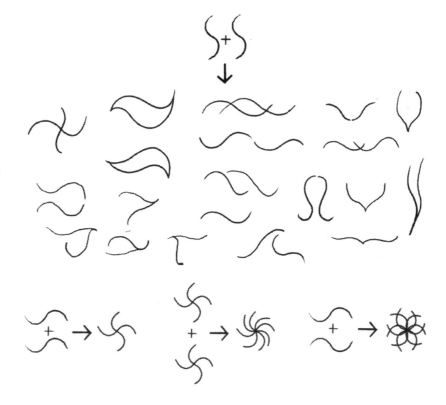

The Line of Balance in 3D

When visualized in three-dimensional space, it can either move in one plane, or spiral like a vortex This perspective enables you to see it in even more ways than before.

IT FORMS MANY PATTERNS OF NATURE

The Line of Balance appears in the patterns of many natural structures and phenomena such as the lungs, placenta, leaves, tree branches, roots, lightning, and even in the nervous and circulatory systems of the body.

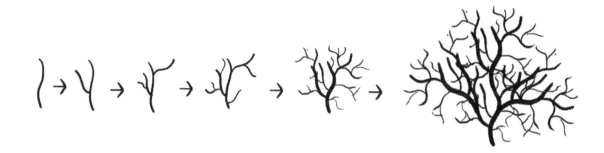

Creating this pattern is pretty easy. Start with one, then add another as a smaller branch of the first, or as an extension. Repeat this until a tree-like network of curves is created. You can also vary the weight of the curves so the main branches are larger than the attached branches. All these examples were drawn with this pattern.

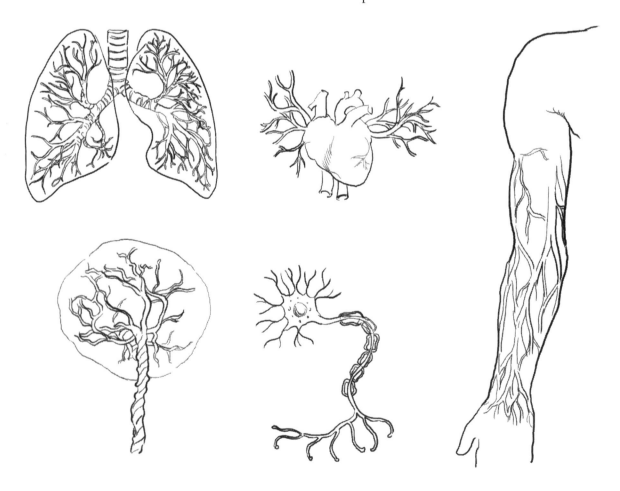

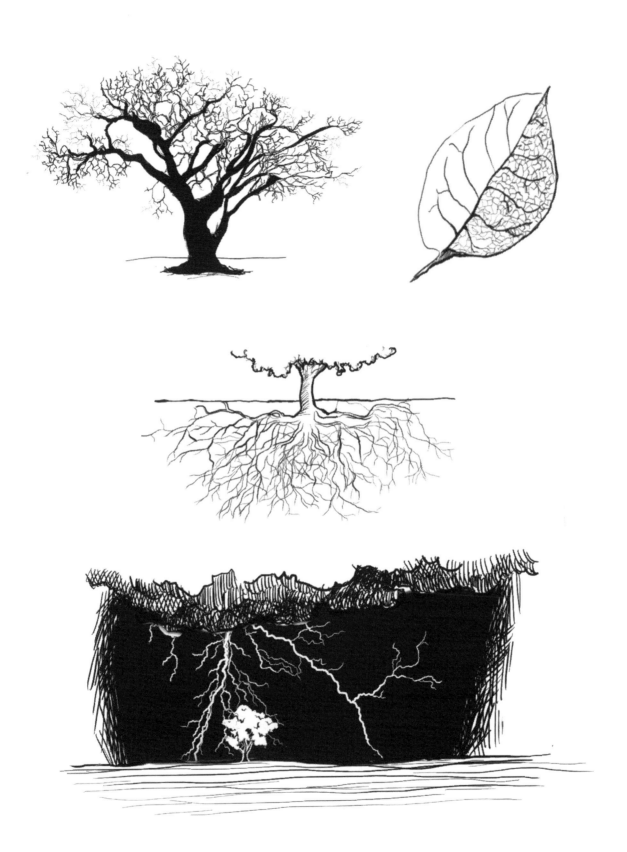

MOVEMENT OF ENERGY AND MATTER

Study the fluctuating motion of flames, rising smoke, and free flowing forms, and you will see they all follow the line's sinuous movement. There is something about it that enables energy and matter to move through space with a high level of stability and efficiency.

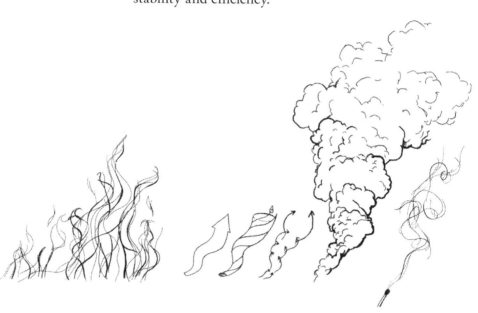

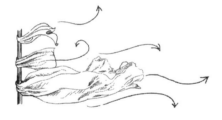

ALL MOTION CREATES A COMMON PATH

Ocean, sound, electromagnetic, and other forms of waves follow this curve in their movement. In addition, all creatures of land, air, and sea also create this sinuate path.

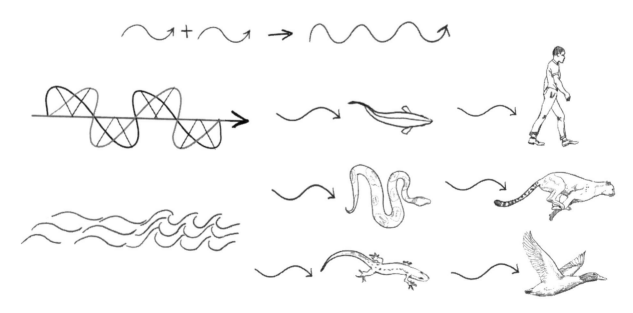

IT IS FOUND IN THE HEART OF A VORTEX

One of the most dynamic examples of the Line of Balance in three-dimensional space occurs in whirlpools and whirlwinds. These and other types of vortices are formed, essentially, from the encounter of opposing, but complementary, forces occurring in moving air, water, or other fluids.

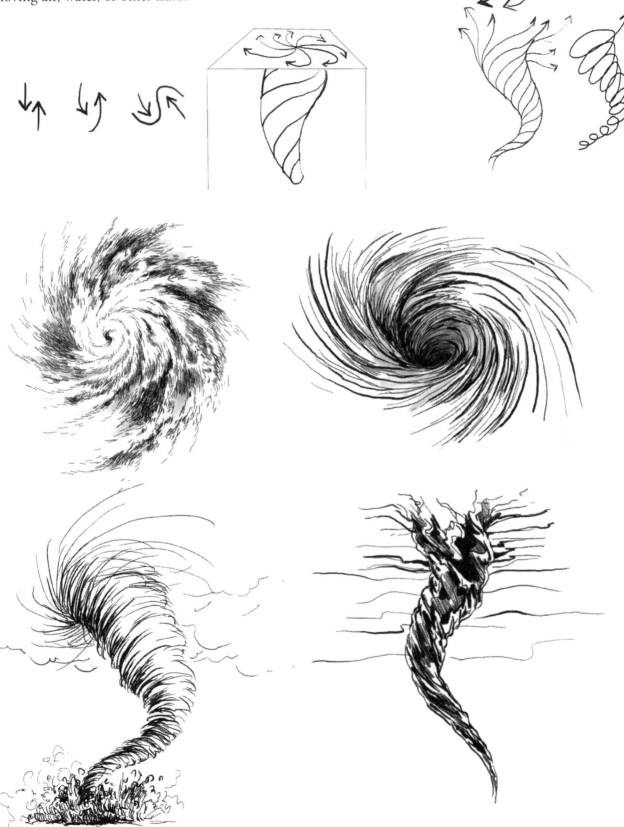

USE IT TO DRAW PORTRAITS

The head's entire contour can be seen as a series of connected Lines of Balance. Practice visualizing the contour of natural forms in this way and you'll find it easier to capture the rhythm of their designs.

USE IT TO DRAW THE FEATURES

It is strongly felt in the contours and design of the facial features as well. Combine two of them, and you have the shape of an eye. This holds true even when the eye is seen from several different viewpoints. The same is true for the contour of the lips, nose, ears, and several facial wrinkles.

ALL HAIR HAS THE SAME NATURAL CURVE

Although you find hair in a variety of textures, from tightly coiled to wavy, it is always sinuous to some degree. Drawing hair with the Line of Balance in mind helps in conveying its natural flow and rhythm.

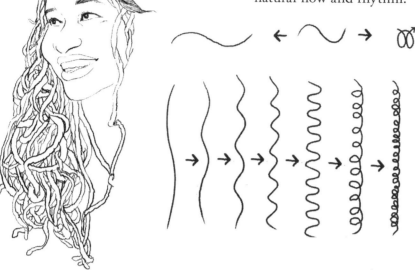

A strand of hair conceptualized with the elasticity of a coil spring. The texture it creates depends on the degree to which it is compressed or extended.

Both beards are rendered with Lines of Balance varied to match their textures.

Hair often appears to spiral from the top of the head like the center of a whirlpool.

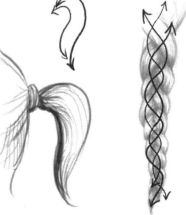

Braided hair can be visualized as woven or interlaced Lines of Balance.

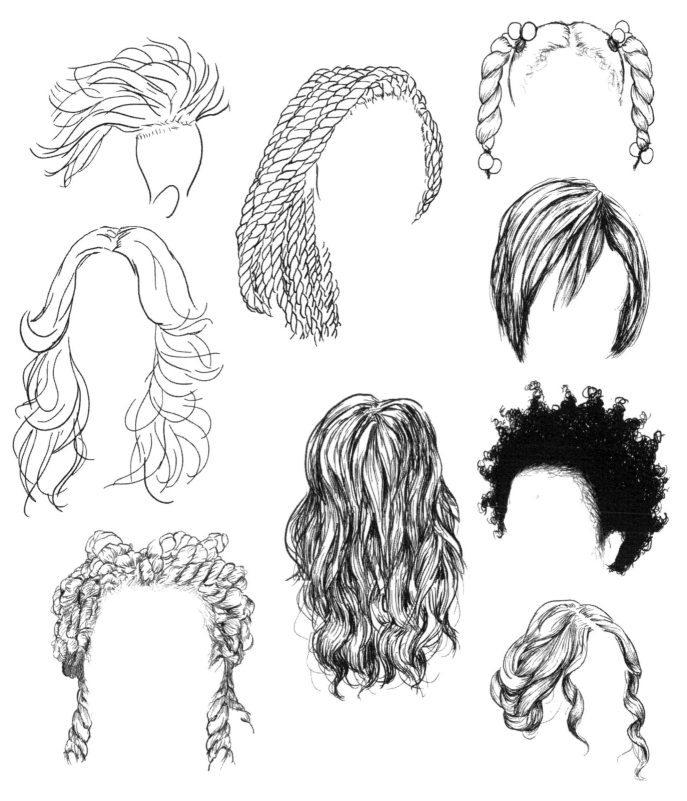

The textures of these hairstyles are all sinuous to some degree. So, styling hair with curls and spirals is just enhancing its natural disposition.

IN THE DESIGN OF THE HUMAN FIGURE

The Line of Balance is found throughout the design of the human body, even at the molecular level in the structure of the DNA double helix. It is also repeated in the shape of the backbone, which helps to give the body its flexibility and the ability to twist and turn. This line is also expressed through the rhythmic counterbalancing of the various masses of the body.

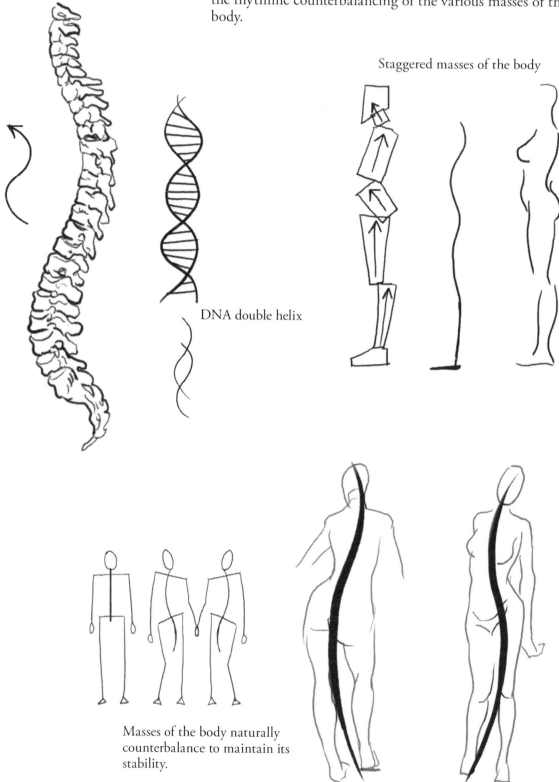

Staggered masses of the body

DNA double helix

Masses of the body naturally counterbalance to maintain its stability.

SPIRALLING BONES AND MUSCLE

The spiralling and twisting actions of muscles as they wrap around the bones and joints help to keep the body stable, while allowing range of motion and flexibility. Follow the cross-contour of the figure's musculature and you will see the Line of Balance all over the body.

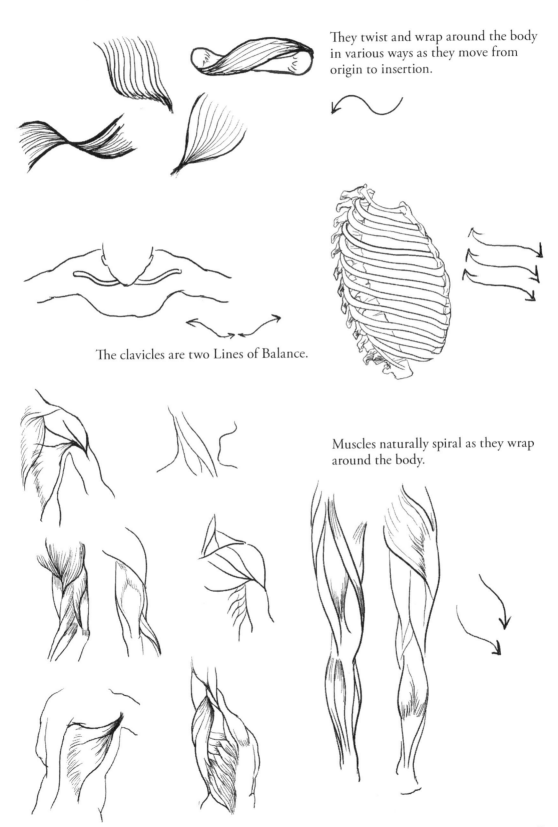

They twist and wrap around the body in various ways as they move from origin to insertion.

The clavicles are two Lines of Balance.

Muscles naturally spiral as they wrap around the body.

LINES OF RHYTHM AND ACTION

The Line of Balance is very useful when doing gesture drawings or quick figure studies. It captures the natural rhythm of the figure and enables you to see the fluidity with which all the mass move together. As a whole, the body moves with a rhythmic and wavelike motion that flows from one end to the other.

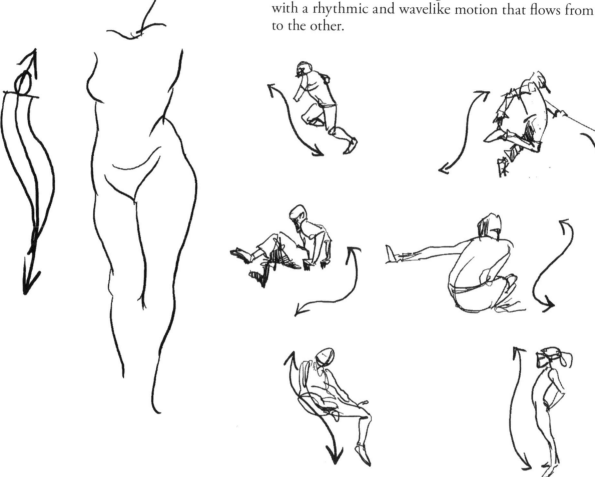

Gesture drawing involves searching for the overall rhythm of a pose.

The Line of Balance can be felt intrinsically within the structure of the figure.

THE FIGURE'S SINUOUS CONTOUR

Like with drawing the head, the figure's contour can be seen as a continuous trail of Lines of Balance, overlapping and flowing into each other.

DRAWING LAND ANIMALS

Animals offer a plethora of opportunities for you to see the Line of Balance at work. In so many instances, the shape of their bodies, tails, necks, ears, tongues, mouths, horns, and other attributes follow this special line.

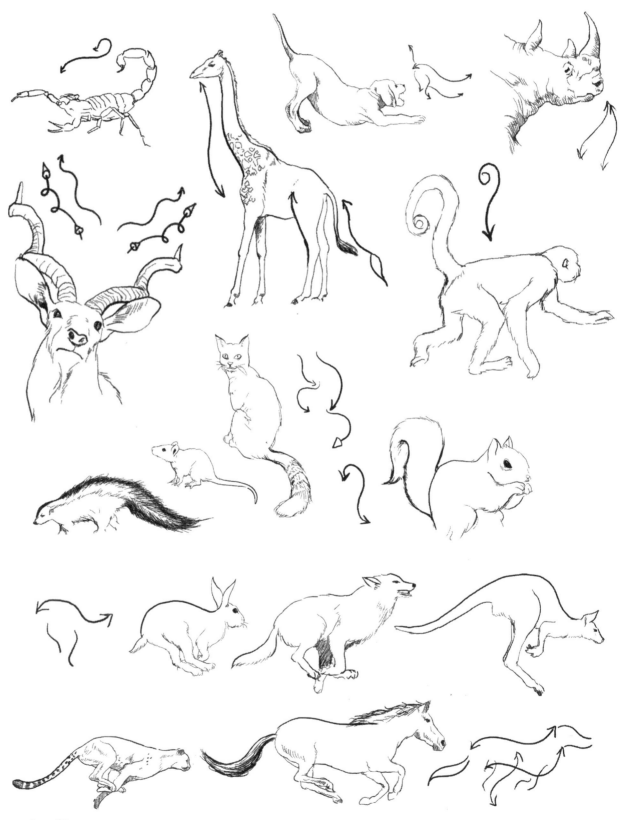

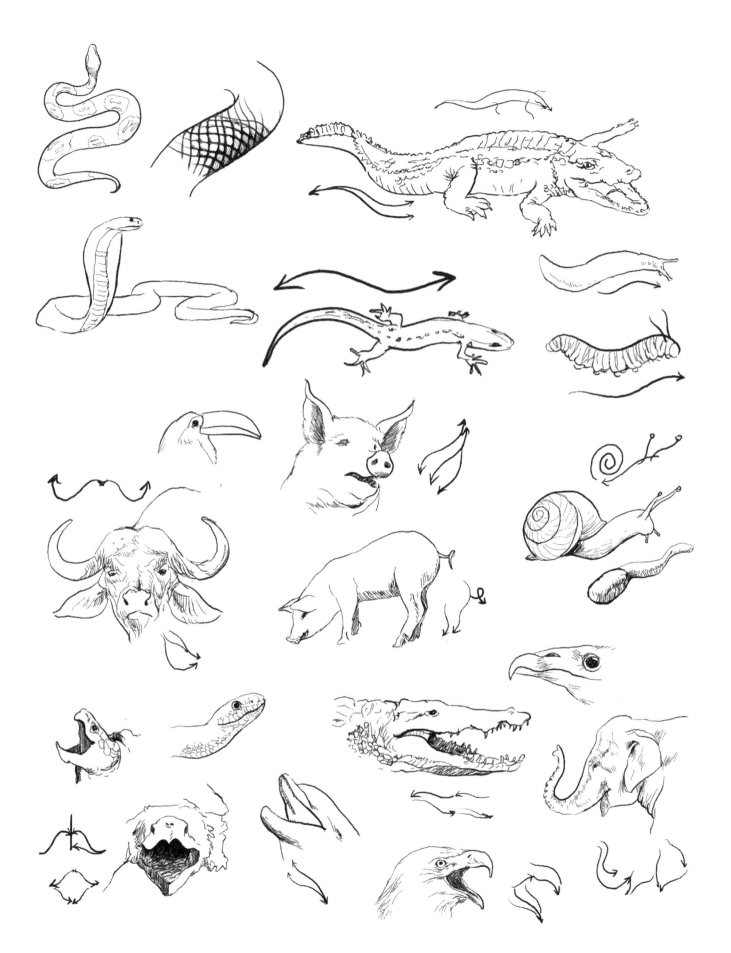

DRAWING ANIMALS OF FLIGHT

Have you ever noticed that the most common way to sketch a bird flying away in the distance is by connecting two Lines of Balance? You can also see this curve in the shape of the necks, bodies, wings, beaks, and feathers of countless birds.

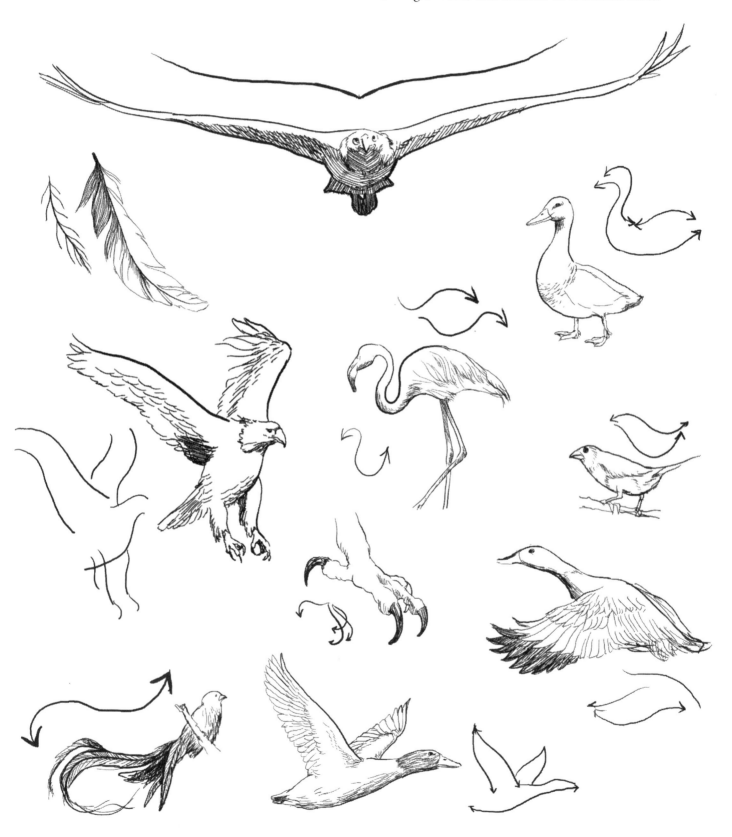

DRAWING SEA CREATURES

The physical attributes of many aquatic creatures are designed with a sinuous curve to enable their efficient movement through water. Observe the design of their fins, flippers, tails, tentacles, and other features and you will find the Line of Balance repeated many times over.

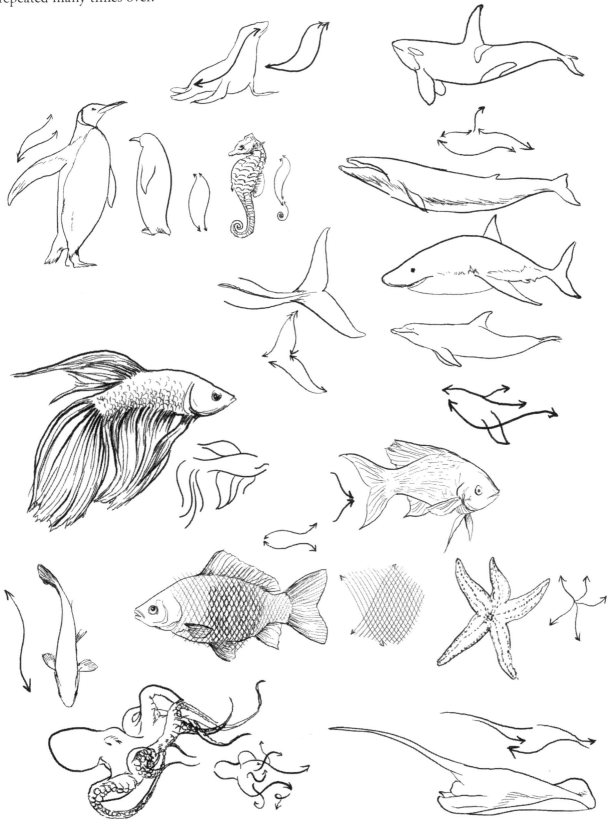

FOUND IN THE DESIGN OF PLANTS

Plants uncover yet another fascinating perspective on the prevalence of the Line of Balance in the shape and design of natural forms. You can see it repeated in the structure of trunks, branches, leaves, flowers, fruits, and even roots.

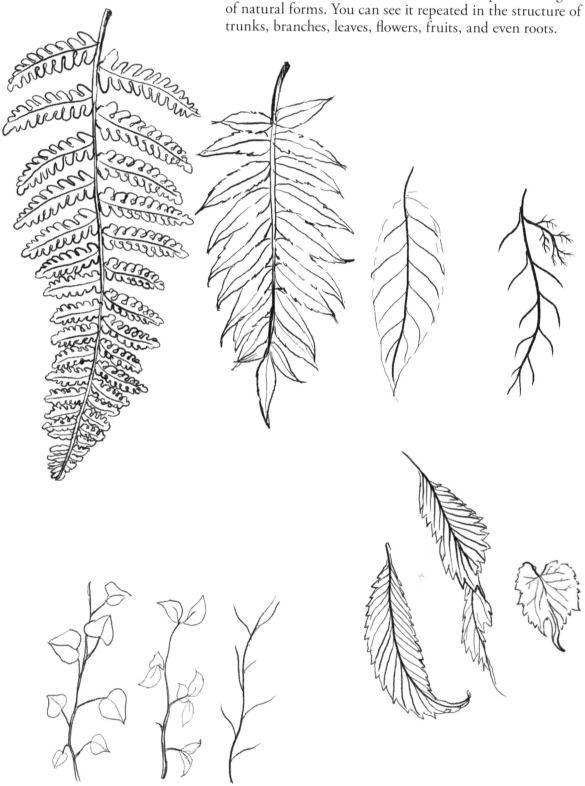

SPIRALLING TRUNKS AND TREES

Some trees have spiralling trunks, while others spiral leaf clusters around their trunks. Leafless trees allow you to witness the sinuous pattern with which their branches develop.

FLOWING FLOWERS

Observe the delicate petals, sepals, and stems of flowering plants and you'll see the how they naturally flow to the rhythm of the Line of Balance.

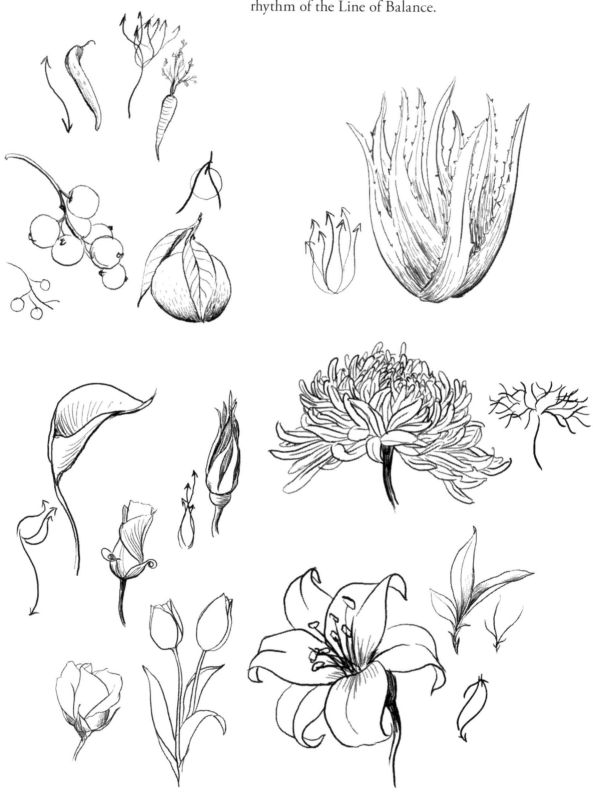

SPIRALLING SUNFLOWERS AND SEASHELLS

The pinecone, sunflower, pineapple, and seashell all share the spiralling design of this amazing line. In this chapter, what you learned about this ubiquitous Line of Balance is meant to inspire your appreciation and understanding of the subtle and sublime harmony embedded within the structures of nature.

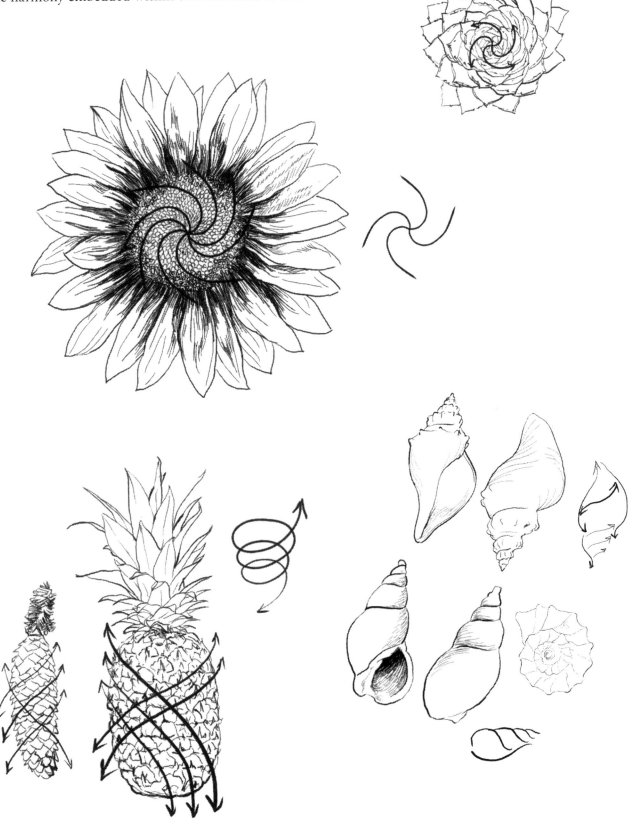

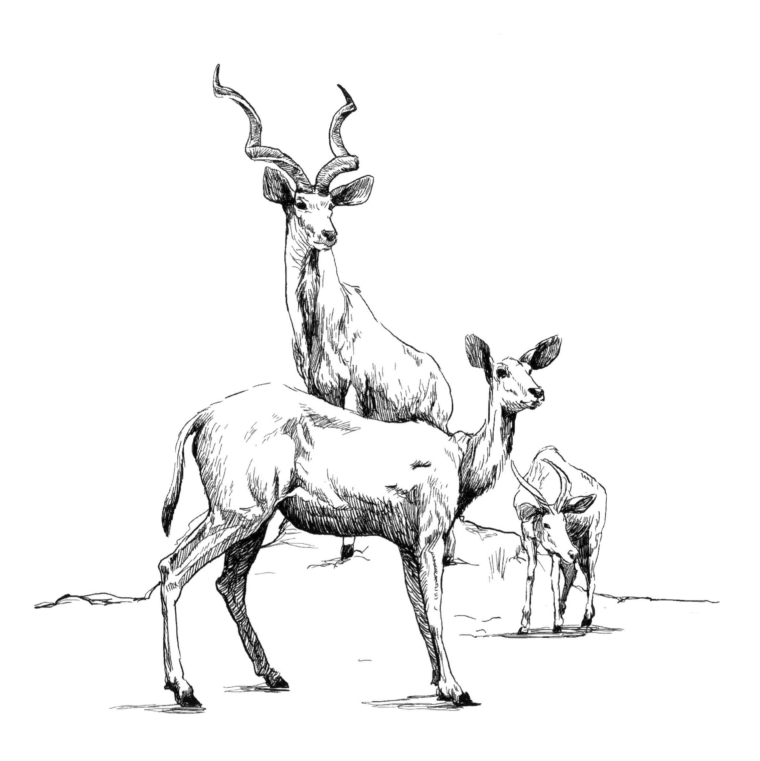

Send-off

Thank you for allowing me to be your guide for this learning experience. I hope you were informed, enlightened, and most importantly, inspired to see new possibilities in your creative potential. I hope you are now fired up to explore this very rewarding medium, and to create wonderful artistic experiences. Keep in mind that progress requires discipline, diligence, and determination, while appreciating how to just have fun. I hope this book will be a treasured guide and companion piece, one you will refer to time and time again.

Good Luck and Happy Drawing,

~A.D.

Index

90561414R00091

Made in the USA
Columbia, SC
05 March 2018